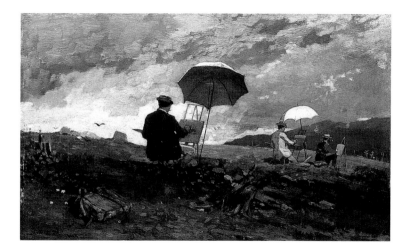

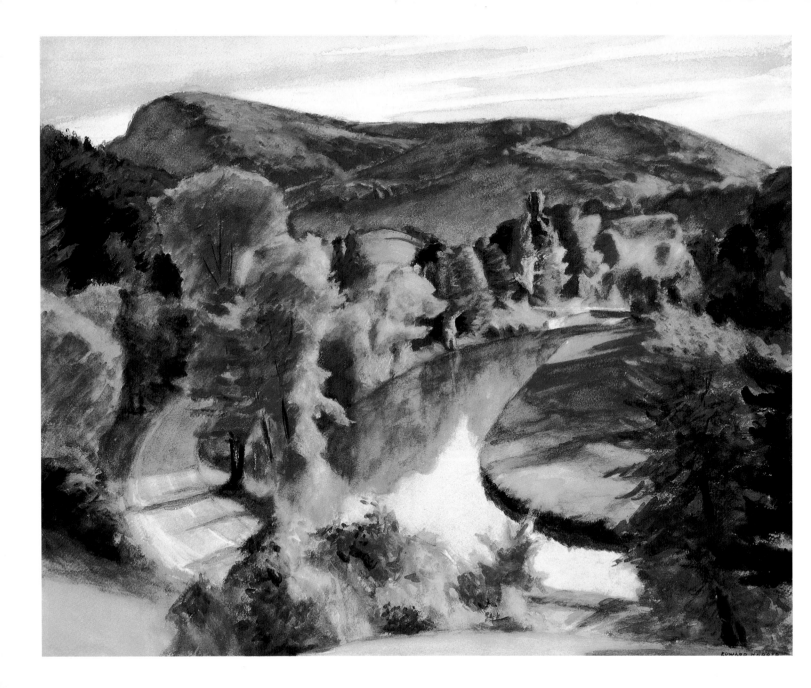

PAINTINGS OF
New England

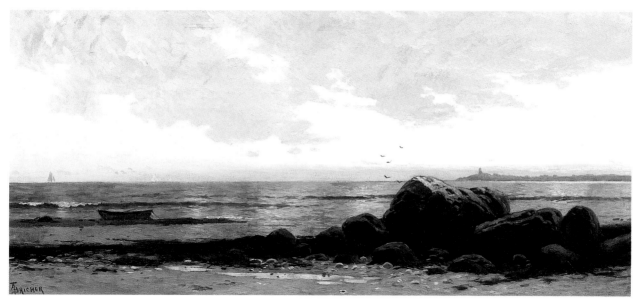

By Carl Little • Series Editor, Arnold Skolnick

DOWN EAST BOOKS, CAMDEN, MAINE, 1996

Copyright © 1996 by Chameleon Books, Inc.
Introduction © 1996 by Carl Little

Published by Down East Books
P.O. Box 679
Camden, ME 04843

Produced by Chameleon Books, Inc.
211 West 20th Street
New York, NY 10011

Production director/Designer: Arnold Skolnick
Editor: Carl Sesar
Editorial assistant: James Creedon
Proofreader: Jamie Nan Thaman
Printed and Bound by O. G. Printing Productions, Ltd., Hong Kong

Library of Congress Cataloging-in-Publication Data

Little, Carl.
 Paintings of New England / by Carl Little ; series editor,
Arnold Skolnick.
 p. cm.
 Includes bibliographical reference and index.
 ISBN 0-89272-384-X (hardcover)
 1. New England in art—catalogs. 2. Painting, American—Catalogs.
I. Skolnick, Arnold.
ND1460.N46L58 1996
758'.9974'0075—dc20 96–21782
 CIP

987654321

(half-title page)
Winslow Homer, *Artists Sketching in the White Mountains,* 1868
Oil on panel, 9 7/16 x 15 13/16 in.

(frontispiece)
Edward Hopper, *First Branch of the White River, VT,* 1938
Watercolor, 19 3/4 x 25 in.

(title page)
Alfred Thomas Bricher, *Point Judith, Narragansett, Rhode Island,* c. 1885
Oil on canvas, 13 x 29 in.

Acknowledgments

"Hillside Trees" and "Autumn Country" from *The Collected Poems of Wilbert Snow,* Wesleyan University Press, 1957.

"The Barn in December" from *Where the Deer Were* by Kate Barnes, David R. Godine Publisher, 1995.

"New England Summer" and "The Northern Summer" from *The Collected Poems of Samuel French Morse,* National Poetry Foundation, 1995.

"Closing the House" from *Poems for Sutton Island* by Hortense Flexner, Port in a Storm Editions, 1994.

Sometime in the 1960s my uncle, the painter William Kienbusch (1914–1980), became intrigued by the crazy quilts made by the women of Great Cranberry Island, Maine. He was drawn to their abstract quality, the fact that they didn't follow a pattern like their traditional counterparts.

The images in *Paintings of New England* make up a kind of crazy quilt. Yes, there are patterns here—recurring motifs, schools of art, generations and legacies—yet each painter puts forth a singular vision of the region.

A daunting task, it was, to stitch together the images that comprise this collection. My personal thanks go to all the artists who helped out, tracking down collectors and transparencies; and I extend my regrets to those many painters who, due to space limitations, will have to wait for volume two.

I am especially grateful to my brother David, a New England artist of the first rank, for lending his home and library to the cause; to Arnold Skolnick, who shared in the exhilarating (and sometimes exasperating) task of choosing these works; and to Tom Fernald of Down East Books who put his faith in this enterprise.

The "backing" for this quilt? Once again my family, Peggy, Emily and James who sustain me through the long New England winters.

Carl Little

Assembling the many beautiful images for this book couldn't have been done without the help of museums, galleries, private collectors, and artists.

I want to personally thank the following institutions that not only sent us the transparencies on time but had them especially photographed for this book: Museum of Fine Arts, Boston; National Gallery of Art; Metropolitan Museum of Art; Hirshhorn Museum and Sculpture Garden; National Museum of American Art; Freer Gallery of Art; New Britain Museum of American Art; Wadsworth Atheneum; Brooklyn Museum; Saint Louis Art Museum; Columbus Museum of Art; Toledo Museum of Art; Cincinnati Art Museum; William A. Farnsworth Library and Art Museum; Portland Museum of Art; Canajoharie Library and Art Gallery; Shelburn Museum; Munson-Williams-Proctor Institute; Dallas Museum of Art; Amon Carter Museum; Terra Museum of American Art; Timkin Museum of Art; Carnegie Museum of Art; Pennsylvania Academy of Fine Arts; Brandywine River Museum; Cape Ann Historical Associations Collections; and the White House Historical Association.

I am also grateful to the university and college collections: Smith College Museum of Art; Mount Holyoke College Art Museum; Colby College Museum of Art; Bowdoin College Museum of Art; Rose Art Museum; and Hood Museum of Art.

Chameleon Books is ever so thankful to the following galleries: Jordon-Volpe Gallery; Fischbach Gallery; Schmidt Bingham Gallery; DC Moore Gallery; Richard York Gallery; Kraushaar Gallery; Tatistcheff Gallery; Aaron Galleries; Alpha Gallery; Chase Gallery; R. Michelson Galleries; David Anderson Gallery; Frost Gully Gallery; and American Illustrators Gallery.

My warm and special thanks to John Driscoll of the Babcock Gallery who went beyond the call of duty in supplying so many of the wonderful images for this book.

I am also indebted to the many private collectors, with special note to: Mr. & Mrs. Barney Ebsworth; Jo Ann & Julian Ganz, Jr.; DeMartine-Fredman; and the Regis Collection.

And finally, many thanks to: David Li; Frances Lui; and Michael Lok; from Oceanic Graphic Printing, who made this book with care.

Arnold Skolnick

Contents

WHEN JOHN STEINBECK SET OUT IN SEARCH OF AMERICA, A JOURNEY THAT LED TO THE PUBLICATION OF *TRAVELS WITH CHARLEY*, HE STARTED IN NEW ENGLAND. GROWING UP IN CALIFORNIA, HE AND HIS CLASSMATES HAD SEEN COLORED PICTURES OF A VERMONT AUTUMN FOREST AND, HE WRITES, "WE

frankly didn't believe it." Motoring through the region in the fall Steinbeck discovered "not only that this bedlam of color was true but that the pictures were pale and inaccurate translations."[2]

New England artists, from the earliest years, have been bewitched by seasonal changes as much as they have been taken by the grandeur of the scenery. The blaze of autumnal colors; the ultimate white of winter; spring's rich greens; the shimmer of sunlight during high summer—the four seasons with their distinct hues have turned many a painter's head and set his or her brush in motion.

In writing about "the gorgeous garb of the American mountains," the great English-born Romantic painter Thomas Cole (1801–1848), inspired by the New England landscape, stated that the beauty of his adopted land outshone that of the Old World. "When the woods 'have put their glory on,' as an American poet has beautifully said," Cole wrote in his famous "Essay on American Scenery" (1836), "the purple heath and yellow furze of Europe's

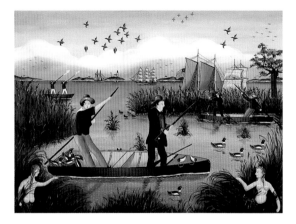

mountains are in comparison but as the faint secondary rainbows to the primal one."[3]

Seasonal color is not the only element of the New England landscape that has inspired artists. The six states—Connecticut, Rhode Island, Massachusetts, Vermont, New Hampshire and Maine—also present incredibly rich and varied motifs—ecosystems, in today's parlance—on which painters can focus their wide-ranging palettes.

New England forests, hills and mountains—the cathedral of the great outdoors—have been of constant appeal since the first pigments were mixed way back when. The configuration of peaks and notches, of ranges stretched across the horizon, of the valleys and intervales in between, of birch groves and woodlands—all have proven irresistible to landscape painters.

George H. Hallowell (1871–1926) was captivated by the forests and by the life of the New England woodsman. In an appreciation of his work, the critic William Howe Downes described his painting *Crown of New England*

RALPH EUGENE CAHOON JR., Duck Hunting, New England, c. 1950, Oil on masonite, 24 x 34 inches

ROCKWELL KENT, Mt. Equinox, Fall, 1921–23, Oil on canvas, 33 x 44 inches

(p. 60) as "a landscape fascinating for its stern northern splendor and almost savage force."[4]

Hallowell's contemporary Edwin Ambrose Webster (1869–1935) resorted to a vibrant, Fauvist-inspired color scheme to paint New Hampshire woods in winter (p. 59). Charles Hovey Pepper stated that Webster's canvases "stagger those accustomed to the neutral as one is staggered by stepping from a dark room into the glare of open day."[5]

The same might be said of Maxfield Parrish's hyper-real landscapes: one commentator recently likened his painting *The River at Ascutney* (p. 101) to "an image of ecstatic Emersonian revelation."[6] Based in Cornish, New Hampshire, a well-known artists' haunt during the early part of this century, Parrish (1870–1966) responded to his idyllic mountain surroundings with paintings that went well beyond the illustrations for which he was acclaimed.

Today, roaming the wilderness back-country of Maine, Neil Welliver (b. 1929) may set his sights on a stretch of the Allagash River, a tree-shrouded stream or a group of lichen-covered erratics, those immense "wandering" boulders that serve as reminders of glacial times (p. 104). Apropos of the latter, it was the great natural historian Louis Agassiz who once noted that New England was, geologically speaking, the oldest spot on the earth's surface.

Needless to say, the range of response to the New England landscape has been remarkable. Another case in point: compare the renderings of Vermont by Milton Avery (1885–1965), Bernard Chaet (b. 1924), Frank Mason (b. 1921) and Houghton Cranford Smith (1887–1983). All four were smitten with the Green Mountain State, yet their personal visions produced a wide variety of images. Avery and Chaet, modernists both, gave the Vermont hills and pasturelands an expressionist glow (p. 95 and p. 93), while Mason, in his sunset view of Peacham, Vermont (p. 49), harks back to George Inness, capturing the waning sunlight that lends atmosphere to the end of day (p. 48). As for Smith, he envisioned a landscape made up of distinct elements, like a cutout (p. 92).[7] These artists painted the same Vermont, yet no two of them pictured it in quite the same way.

OTHER painters have sought and found the essence of New England in its architecture. Edward Hopper (1882–1967) captured the spirit of the region in his many portraits of houses, including the simple cottages that populate the sandy reaches of Cape Cod (p. 81). Drawing upon his constructivist predilections, Hopper's contemporary Niles Spencer (1893–1952) transformed the houses of Provincetown into a handsome design of interlocking shapes (p. 79). One is put in mind of some lines from "Lullaby of Cape Cod" by the late Joseph Brodsky:

> New England towns seem much as if they were cast
> ashore along its coastline, beached by a flood
> tide, and shining in darkness mile after mile
> with imbricate, speckled scales of shingle and tile....[8]

That mainstay of the New England landscape, the barn, has been a perennial favorite subject among artists. Peter Blume (1906–1994) took a constructivist approach in his study of barns in New Hampshire, setting a silo and farm buildings against cloud-like banks of snow (p. 72).

More recently, George Nick and Wolf Kahn (both born 1927) have paid homage to this humblest of structures (pp. 112–113). The former's barn glows in bright winter light, while the latter's could pass for a color-field painting. "A New England barn," the German-born Kahn once stated, "is to us as a Greek temple was to Poussin, a symbol of a whole tradition, laden with all kinds of good associations."[9]

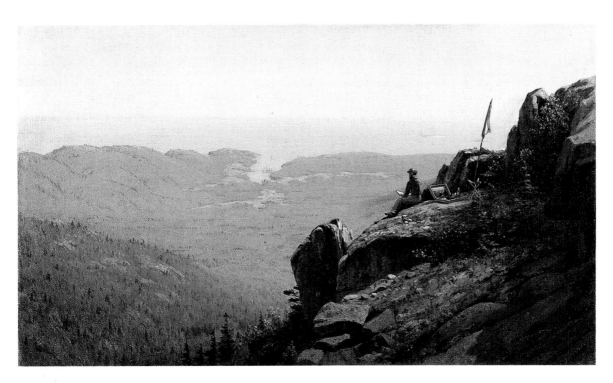

Kahn echoes the sentiments of Childe Hassam (1859–1935), except that this foremost of American impressionist painters was speaking of New England churches, which, he said, have "the same kind of beauty as Greek temples." Hassam was taken with the facade of the First Congregational Church in Old Lyme, Connecticut (p. 66). Old Lyme was a popular gathering place for a number of impressionist painters around the turn of the century.

Churches are as ubiquitous in the art of New England as they are in the actual towns. When Marguerite Zorach (1887–1968) painted a view of Bath, Maine, she placed at center a spire that reaches above the rest of the town, seeming to pierce the sky (p. 90). And the churches and their steeples are among the last objects to catch the strong New England light in the exquisite *Last Light, Old Snow* (p. 10) by Ann Lofquist (b. 1964).

In painting *New England* (p. 111), a somewhat surreal summing-up of a small town, Janice Kasper (b. 1950) quite naturally chose to feature a severe white church, not unlike the house of worship featured in *Midnight Ride of Paul Revere* (p. 110) by Grant Wood (1891–1942). All these churches serve to remind us that the original New England settlers were god-fearing folk who sowed their places of worship across the landscape with the zeal of a Johnny Appleseed.

Artists also found inspiration in New England cities. The rain-swept streets of Boston proved a subject perfectly suited to Hassam's impressionist sensibility (p. 64). His contemporary Maurice Prendergast (1861–1924), working in his signature post-impressionist mode, turned the promenade along Boston's harbor into a radiant mosaic (p. 62).

Farther north, William Wallace Gilchrist (1879–1926) evoked the full fury of a snowstorm in Portland, Maine (p. 65). Congress Square, the heart of Longfellow's "beautiful town/That is seated by the sea," is a blur of swiftly dispatched strokes of paint.

The industrial facades of New England—the factories, warehouses and mills—demanded a different kind of aesthetic. Inspired by primitive painting styles, Stefan Hirsch (1899–1964) practiced a precisionist art that could turn a factory complex in Portsmouth, New Hampshire, into a study in geometry (p. 75).

Like Hirsch, Oscar Bluemner (1867–1938) was drawn to the red brick of industrial buildings. For *Walls of New England* (p. 74), a depiction of warehouses in east Boston, Bluemner chose an especially vivid shade of the color. When the painting was displayed in St. Louis, the director of the City Art Museum requested that the artist withdraw the work, noting that it was "like a cat in a rabbit hutch."

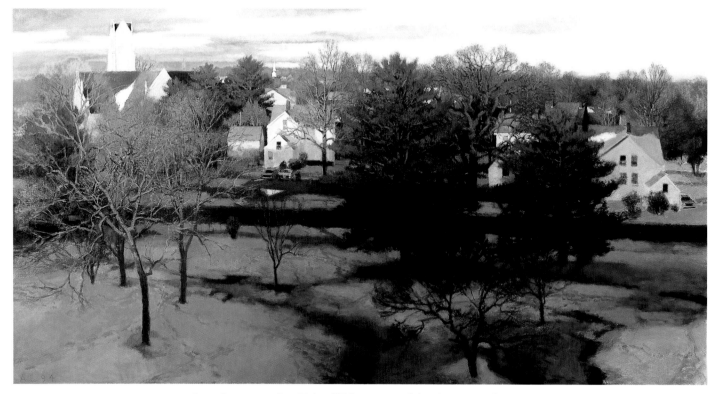

ANN LOFQUIST, Last Light, Old Snow, 1994, Oil on linen, 33 x 63 inches

Bluemner's rejoinder was blunt: "Put [the] red bitch in [the] zoo or firehouse."[10]

More recently, Rhode Island artist Penelope Manzella (b. 1932) has painted a number of remarkable images of mills and factories. *Folding the Run (Griswold Textile Mill, Westerly, RI)* (p. 13) has a surreal quality; the millworkers gather up a great running wall of printed cloth in the ominous shadow of rainclouds. Manzella's is a kind of dream New England.

"THE land itself is the body of New England," wrote historian Monroe Stearns, "so scrawny that the bones of the planet stick through."[11] When Jonathan Fisher (1768–1847) painted his *A Morning View of Blue Hill Village* (p. 30) in 1824, he included, quite prominently, a stone wall, evidence of the rocky northern New England soil.[12] Stretching the length of this wide-angle view, Fisher's wall might be the ultimate prototype—the New Englander's version of the Great Wall of China.

Fisher was one of a number of mainly self-taught artists who in earlier days painted the New England landscape in a simple manner, often setting out to record a particular town or view and, in so doing, preserving for posterity scenes that completely changed in the ensuing years. An early 19th-century image of a New England village painted by an anonymous artist typifies this vision of the townscape of yesteryear (p. 29).

Some of these early limners of the New England scene were essentially sign painters, commissioned to portray a town or a business. G. J. Griffin, who was active in Maine in the 1880s, painted a bird's-eye view of Freeport (p. 28), which looks as bustling in 1886 as it does a hundred years later, although the factories have been replaced by discount outlet stores.

Another of these so-called primitive painters was John Orne Johnson Frost (1852–1929), from Marblehead, Massachusetts. Like Grandma Moses, Frost didn't start to paint till late in life, when he was well into his sixties.[13] For subject matter, he drew upon history and memories of sights from the previous century—among them, a view of Salem Harbor at a time when Indians still came to camp along the shore (p. 31). This primitive image stands in pointed contrast to Prendergast's highly stylized *New England Harbor* (p. 63).

A contemporary of Frost's, Edwin Romanzo Elmer (1850–1923), a farmer from northwestern Massachusetts, is remembered best by a single work, *Mourning Picture* (p. 77), an eerie memorial to his daughter that brings to mind some of the tales of Nathaniel Hawthorne—not to mention the macabre stories of Stephen King. Elmer presents an almost photographic portrait of a New England family, in the yard of a house the artist is said to have built with his own hands. This is American Gothic at its purest.

Such so-called primitive painters continue to work in New England, sometimes maintaining galleries to sell their work. A recent practitioner of the style was Ralph Eugene Cahoon Jr. (1910–1982). With a precise hand and a heart nostalgic for pre-industrial days, Cahoon painted charming images of centuries gone by. His pictures often include a touch of whimsy, as when he painted in mermaids among the rocks of the New England coastline (p. 6).

SOME of the paintings in this book touch on the demographic history of the region. For example, the advent of tourism is recorded in Jerome Thompson's charming *The Belated Party on Mansfield Mountain* (p. 35). Likewise, *Shipping Off Boston Light* (p. 32) by Robert Salmon (1775–c. 1845) captures a turning point in New England

culture: a canoe paddled by natives of this country makes its way amidst mighty New England schooners.

In many cases, the artists played a significant role in the development of the region. It is well known that the paintings of Thomas Cole, Frederic Church and other 19th-century landscape painters, displayed in galleries and museums in Boston, New York and other eastern cities, played a promotional role and led to the establishment of resort areas. As literary historian Van Wyck Brooks has noted, "Most, if not all, of the fashionable American watering-places were first 'found' and colonized by writers and artists."[14]

Paris-born Victor DeGrailly (1804–1889), who was known to copy engravings of other artists' views of New England, brought a foreigner's idyllic vision of the New World to his painting of Eastport and Passamaquoddy Bay in way Down East Maine (p. 34). In contrast to the rugged coast featured in, say, Homer's paintings of Prout's Neck, here all is ordered, even genteel.

The painters of the Hudson River School also brought order—plus drama—to their New England canvases. It was not uncommon for Thomas Cole to rearrange a view to fit the composition he had in mind. Move a mountain a few degrees this way or that—no big deal if the result reflected one's vision of the sublime.

Cole often sought out the most dramatic prospect for his landscapes, as in his famous painting of the Oxbow in Northampton, Massachusetts (p. 40). This scenic vista, which gains its name from the unusual configuration of the Connecticut River, has attracted numerous artists—most recently Stephen Hannock (b. 1951), whose sunset view of the flooded river reflects his kinship with the Luminists (p. 41).

Cole also explored the White Mountains. This grand range would prove to be fruitful territory for a veritable host of landscape painters. Indeed, when Winslow Homer (1836–1910) painted there in the 1860s, the artists were so thick upon the scene that he was inspired to comment upon the situation in a canvas titled *Artists Sketching in the White Mountains* (half-title), in which three painters—virtual mirror images of each other—are shown painting the same view.

Yet these artists had individual visions. By including a horse and rider and an oncoming storm, Cole lent drama to his painting of Crawford Notch (p. 38), which might serve as the background for a Wagner opera. Similarly, the German William Sonntag (1822–1900), who summered in New England, was known to have sought out lesser-known prospects in the area, such as the haunted outpost portrayed in his *Evening in the Mountains* (p. 39).[15]

English-born Edward Hill (1843–1923) included the silhouettes of two hikers to lend a sense of scale to his dramatic view of the snow arch at Tuckerman's Ravine on the east side of Mount Washington (p. 36). At the time artist-in-residence at the Glen House in Pinkham Notch, Hill matched the ruggedness of the famous ravine with forceful brushwork. In a more refined manner, Charles Octavius Cole (1814–1858) painted the equally awe-inspiring *The Imperial Knob and Gorge* (p. 37).

The most frequented spot for painters in the White Mountains was North Conway, site of what many consider to be the first significant artists' colony in America. Writing in 1860, the Reverend T. Starr King noted that the village's

proper distance from the hills that inclose it, and from the Mount Washington range, . . . command various and rich landscape effects. And this no doubt is the great charm of the place to scores of those that pass several weeks of the summer in the village.[16]

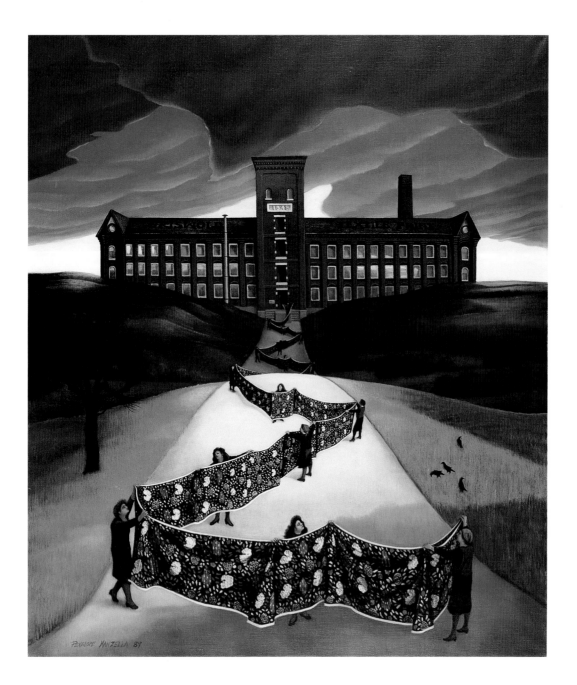

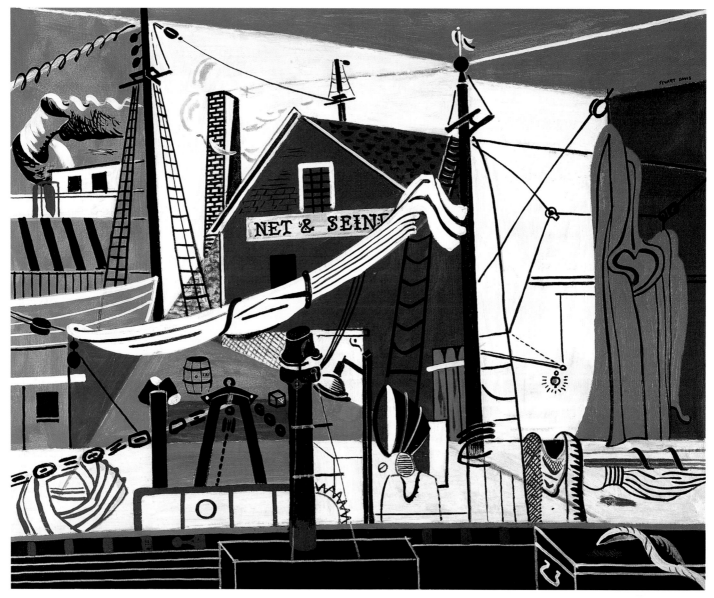

The painting shows the words "NET & SEINE" on a sign.

STUART DAVIS, Landscape with Drying Sails, 1931–32, Oil on canvas, 32 x 40 inches

The bucolic vision of George Inness (1825–1894), who maintained a studio in North Conway for several summers, stands in sharp contrast to the dramatic scenes painted by many of his contemporaries. *Saco Ford, Conway Meadow* (p. 48) reflects his exposure to the work of the Barbizon School artists, even as it exemplifies his atmospheric aesthetic. "The greatness of Art," Inness once stated, "is not in the display of knowledge, or in material accuracy, but in the distinctness with which it conveys the impressions of a personal vital force."[17]

THE painters now commonly referred to as the Luminists also traveled north to find landscapes suited to their interest in dramatic light effects. In the 1860s, on furloughs from fighting in the Civil War, Sanford Robinson Gifford (1823–1880) went on painting excursions through New England, finding temporary peace atop a rocky prominence on Mount Desert Island (p. 9).

Thomas Cole's pupil Frederic Edwin Church (1826–1900) also ventured to Mount Desert Island and, later, Mount Katahdin, but he painted in Connecticut and other areas of New England as well. His view of West Rock near New Haven (p. 42) documents a way of life that has long since disappeared from much of New England.

The art of Fitz Hugh Lane (1804–1865) and that of his near contemporary Martin Johnson Heade (1819–1904) have often drawn comparisons. They both captured a striking stillness in their pictures—even, in Heade's case, if it happened to be the calm that precedes a coastal storm (p. 51).

Lane also excelled at portraits of marine vessels, as witness his *Ships in Ice off Ten Pound Island, Gloucester* (p. 33), said to be his only winter scene.[18] Among Heade's favorite subjects were the marshes in Newburyport, Massa-chusetts, not far from the mouth of the Merrimack River, where one found the great stacks of salt hay that seem so curious to the modern eye (p. 43).

John Frederick Kensett (1816–1872), Worthington Whittredge (1820–1910) and Alfred Thomas Bricher (1837–1908) also preferred to paint untroubled waters. Among their greatest works are the canvases devoted to the expanses of coastline in Rhode Island, flat save for the accents of rock formations. The light was as important as the landscape: Kensett's *New England Sunrise* (p. 50) and Bricher's sunset view of Point Judith (title page) are exemplary Luminist pictures.

It's quite a leap in culture and aesthetics to go from Whittredge's peaceful image of Sakonnet Point in Rhode Island (p. 47) to the hurly-burly of a tennis match in nearby Newport (p. 85) painted by George Wesley Bellows (1882–1925) in the early part of the following century. The times change, and the artists of the day often reflect these cultural shifts in their canvases.

NEW England has bred many formidable realists. Boston-born Winslow Homer stands out among the homegrown painters. In 1883, he settled in Prout's Neck, near Portland, Maine, to paint some of the finest seascapes of all time, including *Watching the Breakers—A High Sea* (p. 53). This rugged promontory continues to attract its off-season admirers; David Little (b. 1951) captures the chill of a winter's day on the shore path at Prout's Neck (p. 52).

Another native-born realist painter, Eastman Johnson (1824–1906) from Lovell, Maine, was taken with the seasonal activities of New Englanders, including maple sugaring and the annual harvest of cranberries on Nantucket (p. 44–45) where he maintained a summer home and studio. Johnson was an island celebrity; each year the Nantucket

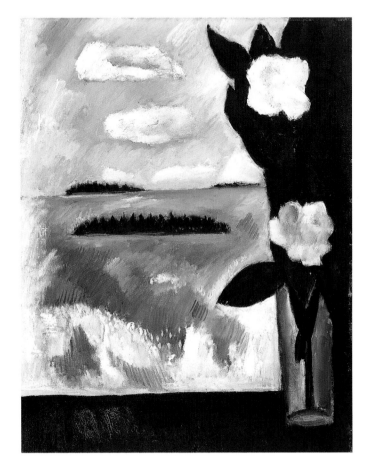

newspapers would note his arrival and he was featured in such coastal guides as Samuel Adams Drake's *Nooks and Corners of the New England Coast* (1875).

This strong realist tradition carried forth into the next century, gaining new force in the work of such artists as Rockwell Kent (1882–1971), Leon Kroll (1884–1974) and N. C. Wyeth (1882–1945). Kent painted throughout New England, with extended stays on Monhegan Island and in New Hampshire, Massachusetts and Vermont. Canvases like *Mt. Equinox, Fall* (p. 7), painted near his home in Egypt, Vermont, and *Snow Fields* (p. 61), a view of the Berkshires, testify to his passion for northern climes.

Kroll, who had once received painting counsel from Homer at Prout's Neck, blended figure and landscape to striking effect in his *Morning on the Cape* (p. 87). Regionalist in feeling, this "humanized landscape," as art historian Alexander Eliot once termed it,[19] reflects the artist's firsthand knowledge of the life of the men and women of Cape Ann, Massachusetts.

Seeking respite from the book work that made him one of the most beloved illustrators of his day, N. C. Wyeth bought a summer home in Port Clyde, Maine (he named the place "Eight Bells" after Homer's famous canvas). In *Walden Pond Revisited* (p. 102), he pays homage to the great New England transcendentalist Henry David Thoreau, picturing him among the Massachusetts woods he so cherished.

N. C.'s son Andrew Wyeth (b. 1917) practices a realism that can be almost photographic in its detail. The painting *Squall* (p. 118) resulted from an experience on an island the artist owned in Maine. As Wyeth has recounted, the painting had its origins in meteorological events:

> A series of squalls came up. Rain beat upon the windows, the sea churned up whitecaps—a chilly feeling....That strange

quality reflected inside the white kitchen became more luminous as the squalls grew stronger....[20]

Andrew's son James Wyeth (b. 1946) has, in turn, taken up the realist mantle, as a portraitist and landscape painter. His *Giant Clam* (p. 19) depicts a South Seas mollusk of enormous proportions transported to the wave-swept shore of Monhegan Island.

Lois Dodd (b. 1927) paints in the same neck of the Maine woods as Andrew Wyeth, yet her brand of representation is decidedly freer, both in palette and technique. She is attracted to the commonplace, which she paints with a lively brush. Like Elizabeth Solomon (b. 1955), who has worked on Cape Cod, Dodd was inspired to paint a clothesline. In their respective hands, this fixture of the New England backyard becomes a lively landscape element (pp. 114–115).

In his painting *Vinalhaven* (p. 128), Thomas Crotty (b. 1934) offers a kind of up-to-date, New England-style version of Watteau's famous *Embarkation for Cythera*. The aesthetic here is nearly photorealist, the Vinalhaven ferry boat dock standing out against a bright Maine summer sky.

Crotty is also a master of the winter landscape, as is his contemporary and friend John Laurent (b. 1921), who makes his home on the southern coast of Maine, in York. In his painting *Nubble Light* (p. 119), Laurent sets this well-known lighthouse at the far end of a wide expanse of pristine snow.

Laurent has had a longtime association with the Ogunquit art colony, which has attracted a multitude of painters over the years.[21] Beatrice Whitney Van Ness (1888–1981) studied there with Charles H. Woodbury (1864–1940), emulating his painterly approach to landscape in such canvases as *Whitecaps* (p. 55), a view looking toward the Camden Hills from the island of North Haven.

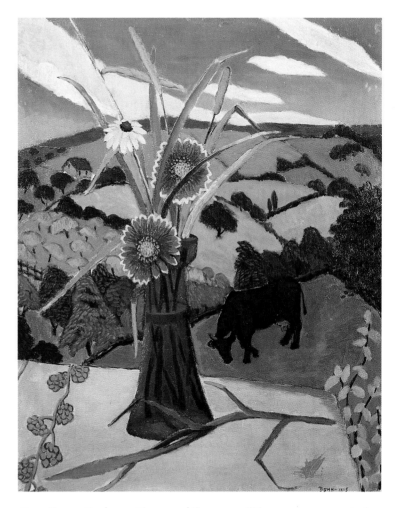

BEN BENN, Landscape, Flowers and Cow, 1915, Oil on canvas, 27 x 22 inches

Woodbury himself was a master of marine subjects, including a motion-filled image of women in the surf (p. 82).

Beverly Hallam (b. 1923) has close ties to Ogunquit as well. She first visited in the 1930s and returned in the late 1950s, eventually settling in nearby York. Exploring the coast, the tide pools and cliffs became a favorite pastime and led to the creation of such astonishing pictures as *Big Mussel* (p. 18).

OF the European schools of art that influenced the art of New England, perhaps none was more powerful than impressionism. The region's special quality of light and range of seasonal color encouraged, if not demanded, painting in this style. Willard Leroy Metcalf (1858–1925), once called "the poet laureate of the New England hills," was especially adept at capturing the light, be it sunshine filtered through trees or moonglow lighting up the boughs of lilac bushes (p. 67).

When the painter J. Alden Weir (1852–1919) first viewed impressionist art in Paris in 1877, he responded with outrage. "I never in my life saw more horrible things," he reported to his parents. "It was worse than the Chamber of Horrors."[22] Not many years later Weir ate his words, as he embraced this revolutionary aesthetic, painting some of his best-known canvases at his farm near Branchville, Connecticut (p. 71).

This sylvan setting, which came to be known as the Land of Nod for its fairy-tale quality, drew a number of other artists. John Henry Twachtman (1853–1902) and Childe Hassam were both regular visitors, and the great mystic painter Albert Pinkham Ryder (1846–1917) made several visits. As art historian Elizabeth Broun has noted, the Arcadian countryside led Ryder to paint some of his "largest pure landscapes," such as *Weir's Orchard* (p. 99).[23]

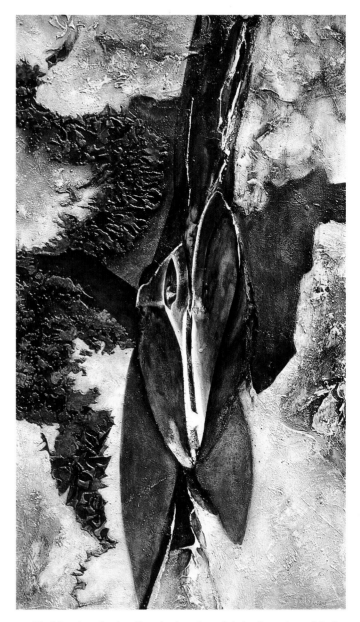

BEVERLY HALLAM, Big Mussel, 1965, Acrylic and mica talc on Belgian linen, 84 x 48 inches

"To be isolated is a fine thing and we are nearer then to nature," Twachtman once wrote to Weir. He was especially taken with the wintry aspect of the New England landscape. As he wrote,

> Never is nature more lovely than when it is snowing.... Everything is so quiet and the whole earth seems wrapped in a mantle.... All nature is hushed to silence.[24]

Although modernist through and through, Edwin Dickinson (1891–1978) was drawn to similar atmospheric qualities in nature, as attested to by his dreamlike *Lieutenant Island from Indian Rock* (p. 80). Painted *au premier coup*, this canvas is one of a series of small pictures of Cape Cod, each of them featuring mist-shrouded stretches of sand and sky.

Many artists working in an impressionist mode were drawn to coastal prospects. Working at Halibut Point, just north of Folly Cove in Gloucester,[25] Joseph DeCamp (1858–1923), a member of the Boston School of painters, painted a lovely, wind-swept day, with waves tossing their whitecaps across the water (p. 54).

Another brand of impressionism is found in the canvases of William J. Glackens (1870–1938). Looking at his *Beach Scene, New London* (p. 84), one understands how he gained the title "The American Renoir." Carroll Tyson (1878–1956), who had visited Monet at his home in Giverny, worked in the Mount Desert Island area during the first half of the century. Among his subjects was the stonecutting operation at Hall's Quarry on Somes Sound (p. 109). This painting now hangs in the White House.

CERTAIN New England locales have become renowned for the sheer multitudes of artists they have attracted and

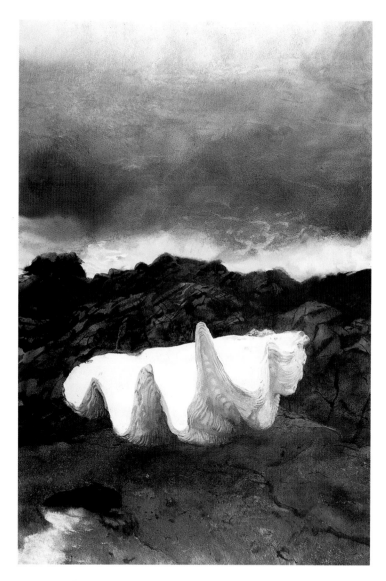

James Wyeth, Giant Clam, 1977, Watercolor on paper, 34 x 23 inches

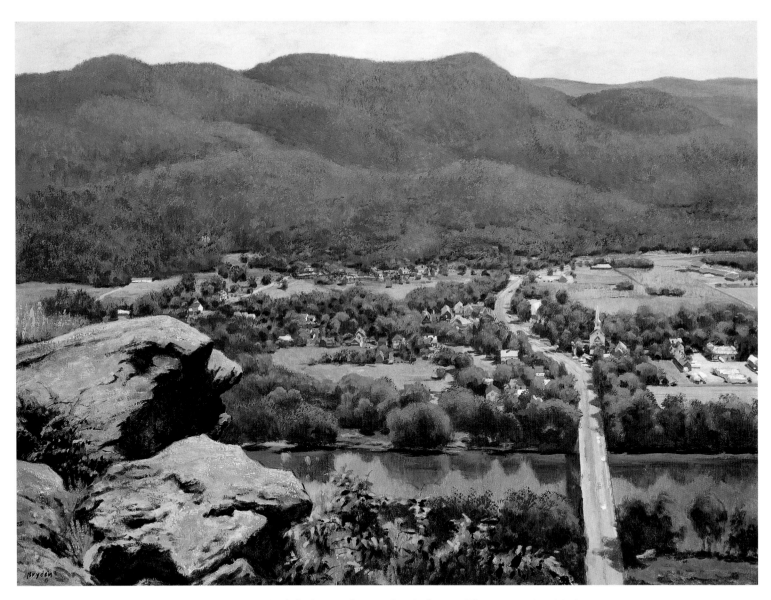

LEWIS BRYDEN, Sunderland—View from Mt. Sugarloaf, 1994, Oil on canvas, 28 x 38 inches

inspired. One such place is Gloucester, Massachusetts. Well known as a base for the New England fishing industry, this town and its picturesque surroundings have attracted hundreds of painters—to the point that William Meyerowitz (1887–1981) was inspired to paint his delightful *Gloucester Humoresque* (p. 68), in which the landscape is practically overrun by artists and their easels. As John Sloan (1871–1951) wrote, "There was an artist's shadow beside every cow in Gloucester, and the cows themselves were dying from eating paint rags."[26]

Homer, Hopper, Hartley, Hassam—the list of Gloucester artists, in the H's alone, is a long and distinguished one. In many cases, these painters were seeking refuge from the big city and were inspired to create pictures quite unlike those for which they were most famous. Take Sloan: as a member of the Ashcan School, he had made a name for himself through depictions of city dwellers sweating it out on rooftops, of backyard clotheslines in the heart of the urban jungle. Yet the summers of 1914–1918, spent in Gloucester, found him working directly from nature, creating such pure landscapes as *Red Rocks and Quiet Sea No. 2* (p. 56).

Sloan was especially drawn to Dogtown (p. 57), a boulder-strewn moor on Cape Ann that also inspired Marsden Hartley (1877–1943) and William Kienbusch (1914–1980) to paint some of their finest landscapes. Hartley once described Dogtown as looking like "a cross between Easter Island and Stonehenge."

Philadelphia-born Stuart Davis (1892–1964) first brought his cubist-inspired aesthetic to Gloucester in 1914. Calling himself "a continuing addict of the New England coast," Davis found the light especially beneficent to practicing his "color intervals." Of the schooner masts in Gloucester harbor he wrote, "They make it possible for the novice landscape painter to evade the dangers of taking off into the void as soon as his eye hits the horizon."[27]

Around this same time, some of the painters commonly called the American Modernists were doing some of their greatest work in the hinterlands of New England. John Marin (1870–1953) set up studio at Cape Split, in the Down East town of Addison. Like many an artist, Marin was struck by the sea that so forcefully made its presence known (p. 107). In a letter from Maine in July 1939, he wrote,

> So maybe I'll start painting—if I do—I shouldn't wonder but what I'd paint—Rocks—Sea—Sky—and Earth—and I'll probably use plenty of paint—like the feller up here said about baking beans—plenty of pork—plenty of pork—plenty of pork.[28]

Marin's contemporary, Maine-born Marsden Hartley, once likened New England to "a first wife that one cannot help revering—& yet cannot possibly live with," which explains his on-again, off-again relationship with the region. He did some of his finest work in his native state, including the combination landscape and still life *Windy Day, Maine Coast* (p. 16). Ben Benn (1884–1983) achieved a similar blending of genres in his *Landscape, Flowers and Cow* (p. 17).

Apropos of his canvas *Smelt Brook Falls* (p. 96), Hartley wrote in a letter that he had "hopes at one time or another to have a show of nothing but waterfalls, as I love them so much."[29] Maine painter Alan Bray (b. 1946) shares this passion, as witness his *Wilson Falls* (p. 97).

Hartley's friend Carl Sprinchorn (1887–1971) spent many a season, including winter, in the interior of Maine, sometimes staying in the logging camps. "Now may be seen what the Maine woods region looks like through the

eyes of [a] considerate painter," wrote Hartley in the early 1940s. "I recommend [Sprinchorn's paintings] as I would recommend pork and beans and clam chowder...."[30]

Hartley and his fellow modernists had a profound influence on the next generations of artists, including the abstract expressionists. William Kienbusch, who read Marin's letters while still in prep school, practiced an abstraction founded on elements of the New England landscape, including islands, fishing weirs and gong buoys. For many years, Kienbusch kept a rowboat in Stonington, on Deer Isle, and would row it out into Penobscot Bay (p. 106) to spend the day exploring the islands.

Kienbusch's close friend Karl Schrag (1912–1995) worked on Deer Isle for nearly fifty summers, painting expressionist landscapes such as the striking image of a sandbar (p. 122). "Nature appears in the painting...as it is remembered," Schrag once wrote, "rather than as it is seen."[31]

EVEN as these modernist painters and their followers were transforming the landscape tradition, other artists fixed upon a vision of New England shaped by a distinctive regionalist perspective. In many of her images of Connecticut, Lauren Ford (1891–1973) captured the ambiance of a country way of life, in the days when doctors made house calls by horse and buggy, when children gleefully rode atop the hay wagon, and houses and farms fitted so neatly—and aesthetically—into the landscape (p. 69).

Images like these underscore the myth of New England as much as they do its reality. Looking at these paintings, one yearns for the days before A-frames and design statements, shopping malls and gas stations marred the landscape.

Another painter enamored of rural life was Paul Starrett Sample (1896–1974). His images of Vermont villages sometimes read as summary statements of the culture of the people. A canvas like *Beaver Meadow* (p. 76) contains all the elements of the small New England village, from the white church, graveyard and farm to the straight-backed grandmother, studying, one suspects, her scriptures. This and other related works, art historian Robert L. McGrath has written, "served to project what was to become an archetypal vision of the Vermont countryside into the American consciousness."[32]

Other so-called regionalist artists, such as Grant Wood and Thomas Hart Benton (1889–1975), brought a stylized aesthetic to bear on the New England countryside. Benton spent many summers on Martha's Vineyard; his view of Menemsha Pond (p. 86) could be seen from his front yard and several of the figures are based on real-life individuals, including the artist's wife, Rita, shown wearing a dark blue bathing suit. An earlier canvas, *The Cliffs* (p. 88), reflects a modernist vision of the shoreline of Martha's Vineyard.

In more recent days, Martha's Vineyard has attracted Allen Whiting (b. 1946), whose *Oak Trees at Big Sandy* (p. 127) was painted at Chilmark. Where Benton rarely painted a landscape without figures, Whiting chose a prospect void of any signs of civilization.

Daniel Lang (b. 1932) finds a middle ground in many of his paintings of New Hampshire and Vermont. Several works feature an Adirondack chair, symbol of New England repose, set in a moonlit clearing (p. 126). While no figure is present, these scenes are redolent of human presence.

"ISLANDS possess, of themselves, a magnetism not vouchsafed to any spot of the main-land. In cutting loose from the continent a feeling of freedom is at once exper-

enced."[33] So wrote Samuel Adams Drake in 1875, and the sentiment remains as strong, if not stronger, today, especially among artists.

Drake also wrote that "the most famous island you can find on the New England map is Monhegan Island." As related in the recently published *Monhegan: The Artists' Island*, painters started arriving on this isolated island off the coast of Maine in the mid-1800s and never stopped.[34] Nearly every school of art has been represented, from the Hudson River right up to geometric abstraction.

When he first visited the island in the early 1960s, John Hultberg (b. 1922), a visionary abstractionist, found inspiration for several landscapes, including the memorable *Daybreak Over Island* (p. 91). In 1969, the artist made a list of "happy moments" in his life, one of which was "lying in my hammock under the elm tree on Monhegan."[35]

Despite overdevelopment and the arrival of boatloads of tourists every summer, Monhegan Island has lost little of its allure. David Vickery (b. 1964), who was awarded a Carina House fellowship to paint on Monhegan in 1993, spent his residency drinking in the island and its famous

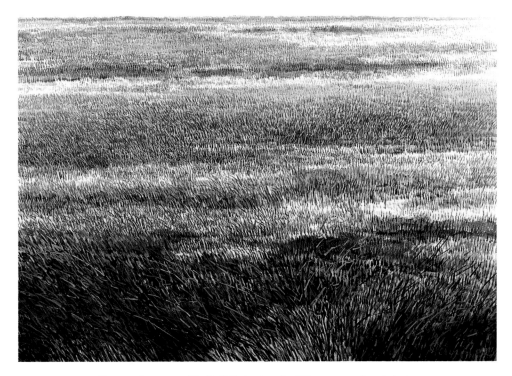

GABOR PETERDI, Big Red Wetland, 1982, Oil on canvas, 60 x 80 inches

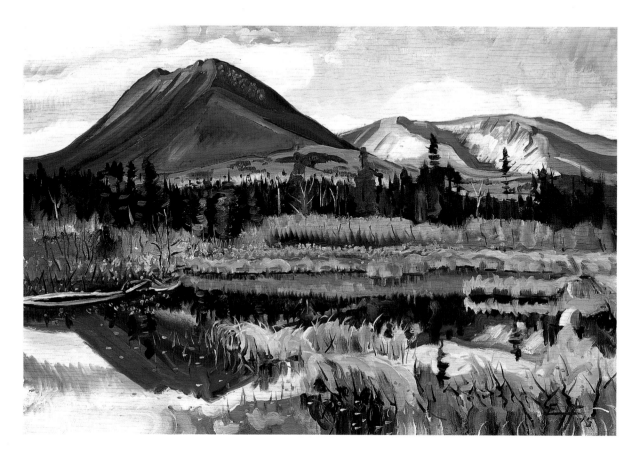

views. That he managed to say something new is evident in the painting *Kate on Gull Rock, Monhegan* (p. 116).

Following a number of highly productive summers painting on Monhegan, George Wesley Bellows made a trip to nearby Matinicus, where, to his pleasure, he found "no summer people whatsoever."[36] His painting of the Matinicus harbor with a pair of oxen (p. 70) recalls a way of life that has, for the most part, disappeared from Maine islands, although today some islanders are returning to agriculture and livestock in search of sustainable livelihoods.

THE New England landscape has changed dramatically over the centuries, but in recent decades the alterations have seemed to happen faster and with greater fury. The National Trust for Historic Preservation placed the state of Vermont on its list of Most Endangered Places in 1993, with Cape Cod added the following year.[37]

CHRISTOPHER HUNTINGTON, The Mountain, c. 1980, Oil on canvas, 16 x 24 inches

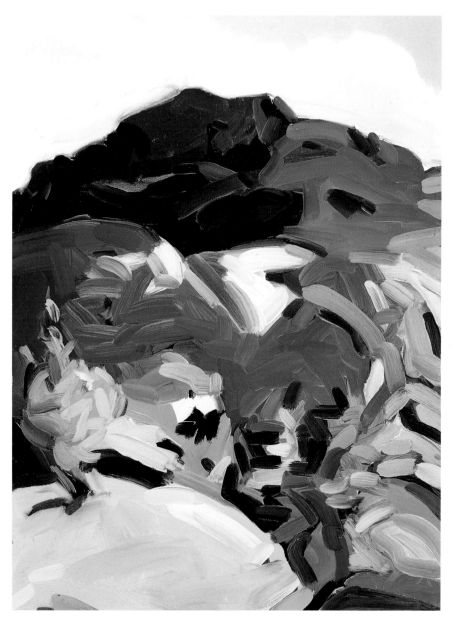

HENRY ISAACS, Mt. Mansfield from Johnson, VT, #2, 1991, Oil on canvas, 24 x 18 inches

In Maine, a referendum to stop clear-cutting and a proposal to establish a national park in the north woods reflect a growing concern about the future of what is left of New England wilderness. At the same time, many conservation and land trust organizations have taken up the cause of preservation.

A number of contemporary artists have commented on this situation in their work. David F. Utiger (b. 1957), who lives in Peru, Vermont, thinks of his art "as a humble attempt to fight back against an increasingly mass marketed, mass-produced and banal world." In his haunting *City on the Hill* (p. 121), which displays the kind of planned order of the earliest townscapes in this book, he tried, he says, "to depict a New Jerusalem in a New England setting."[38]

Another artist who works in Vermont, Henry Isaacs (b. 1951) prides himself on the fact that he does most of his work *en plein air*. His painting of Mount Mansfield, the tallest peak in the state, makes for a powerful configuration of bold and lively brush strokes (p. 25). There is a purity in Isaacs' paintings, as there is in the woodscapes of Margaret Grimes (b. 1943), that in and of itself makes a statement about the grandeur of the out-of-doors and the need to preserve it. Grimes, who has also done her share of winter landscapes, captures the profusion of summer foliage in her tour de force *Wild Grape* (p. 105).

In his landscapes of the Pioneer Valley in Massachusetts (p. 20), Lewis Bryden (b. 1944) has been known to edit out "all the accumulated debris of modern life,"[39] including cars, telephone poles and road signs. Elsewhere, Gabor Peterdi (b. 1915) has paid his painter's respects to the beautiful—and besieged—wetlands along the coast of Connecticut (p. 23).

Artists continue to be drawn to the motifs that attracted their forebears. Christopher Huntington (b. 1938) has found the same pleasure setting up his easel before Mount Katahdin (p. 24) as did Church, Hartley and the many other artists who have made the trek to view New England's second highest peak. On the coast, Joellyn Duesberry (b. 1944) and Ernest McMullen (b. 1942), who have worked on Mount Desert Island for many years, bring the same kind of passion to painting the area, including Cadillac Mountain (p. 108 and p. 117), as did the painters who frequented the island in the 1800s.

Many contemporary landscape painters have, in a manner of speaking, gone back to the land—the coast, the mountains, the islands of New England—paying tribute to landscapes that, so far, have managed to survive the onslaught of development. They might be heeding the words of Henry Beston, in the final lines of *The Outermost House* (1928):

> Touch the earth, love the earth, honour the earth, her plains, her valleys, her hills, and her seas; rest your spirit in her solitary places. For the gifts of life are the earth's and they are given to all, and they are the songs of birds at daybreak, Orion and the Bear, and dawn seen over ocean from the beach.[40]

They might also be seeking that sense of wonder that Captain James Smith experienced as he cruised the shore of Massachusetts Bay in 1616. "Of all the four parts of the world I have yet seen not inhabited,..." he wrote, "I would rather live here than anywhere."

New England lives on in its art and artists. Long live New England.

Carl Little
Mount Desert Island, 1996

Footnotes

1. Howard Nemerov, *New and Selected Poems,* University of Chicago Press, 1960.

2. John Steinbeck, *Travels with Charley,* New York: Viking Press, 1962, pp. 34–35. The author also wrote: "There are enough antiques for sale along the roads of New England alone to furnish the houses of a population of fifty million" p. 36.

3. Thomas Cole, "Essay on American Scenery," 1836, reprinted in *The Book of Nature: American Painters and the Natural Sublime,* Hudson River Museum, 1983.

4. William Howe Downes, "George H. Hallowell's Pictures," *The American Magazine of Art,* Vol. XV, No. 9, September 1924.

5. *The Armory Show Years of E. Ambrose Webster,* Babcock Galleries, 1995.

6. Ken Johnson, "Kitsch Meets the Sublime," *Art in America,* March, 1996.

7. In an appreciation of Smith, the critic Hilton Kramer noted the "clarity and stillness" in his later paintings and their "strange, otherworldly quality." *Houghton Cranford Smith: Selected Paintings,* Grace Borgenicht Gallery, May–June 1994.

8. Joseph Brodsky, *A Part of Speech,* New York: Farrar Straus Giroux, 1977.

9. Alan Gussow, *A Sense of Place: The Artist and the American Land,* Friends of the Earth, 1970.

10. Cited in *50 Recent Acquisitions,* Jordan-Volpe Gallery, 1990.

11. Monroe Stearns, *The Story of New England,* New York, Random House, 1967.

12. Mary Ellen Chase, *Jonathan Fisher, Maine Parson 1768–1847,* New York, The Macmillan Company, 1948. "The painting of Bluehill in 1824 was sketched in the autumn of that year and completed in May 1825. He [Fisher] writes his mother about it with some enthusiasm, saying, however, that he thinks it the last large picture he will paint" p. 229.

13. A large collection of Frost's pictures, many of which were done in house paint on common board, are in the collection of the Marblehead Historical Society.

14. Van Wyck Brooks, *The Flowering of New England 1815–1865,* E.P. Dutton & Co., Inc., 1936, p. 406.

15. Donald D. Keyes et al., *The White Mountains: Place and Perceptions,* University Press of New England, 1980.

16. Cited in Robert L. McGrath and Barbara J. MacAdam, *"A Sweet Foretaste of Heaven": Artists in the White Mountains 1830–1930,* University Press of New England, 1988, p. 30.

17. Gussow, *A Sense of Place,* 1970.

18. John Wilmerding, *American Marine Painting,* New York, Harry Abrams, 1968.

19. Alexander Eliot, *Three Hundred Years of American Painting,* Time Incorporated, New York, 1957.

20. Andrew Wyeth, *Autobiography,* Little, Brown and Company, Boston, 1995.

21. Louise Tragard et al., *A Century of Color: Ogunquit, Maine's Art Colony, 1886–1986,* Ogunquit, Barn Gallery Associates, 1987.

22. Patricia O'Toole, "Walk this trail to see what inspired the American Impressionist painters" (on J. Alden Weir's Connecticut farm), *Smithsonian,* February 1996.

23. Elizabeth Broun, *Albert Pinkham Ryder,* Smithsonian Institution Press, 1989.

24. Gussow, *A Sense of Place,* 1970.

25. Information provided by the Farnsworth Museum per Laurene Buckley.

26. Cited in Carter Ratcliff, *The Gloucester Years,* Grace Borgenicht Gallery, 1982.

27. Bennett Schiff, "Stuart Davis Was Modern Right Down to His Very Roots," *Smithsonian,* December 1991.

28. Dorothy Norman, ed., *The Selected Writings of John Marin,* New York, Pellegrini & Company, 1949.

29. Gussow, *A Sense of Place,* 1970.

30. Gail Scott, *Carl Sprinchorn,* Tom Veilleux Gallery, Farmington, Maine, 1994.

31. Suzette McAvoy, *Karl Schrag: A Retrospective Exhibition,* Farnsworth Museum, Rockland, Maine, 1992.

32. Robert L. McGrath, *Paul Sample, Painter of the American Scene,* Hood Museum of Art, Hanover, New Hampshire, 1988. McGrath describes *Beaver Meadow:* "In this splendidly resonant canvas we encounter the artist in full possession of his resources, the Regionalist vision in its most compelling form."

33. Samuel Adams Drake, *Nooks and Corners of the New England Coast,* New York, Harper and Brothers, 1875.

34. Will and Jane Curtis with Frank Lieberman, *Monhegan: The Artists' Island,* Down East Books, Camden, Maine, 1995.

35. Shirley Jacks et al., *John Hultberg: Painter of the In-Between,* Emerson Gallery, Hamilton College, Clinton, New York, 1985.

36. Cited in Jessica F. Nicoll, *The Allure of the Maine Coast: Robert Henri and His Circle, 1903–1918,* Portland (Maine) Museum of Art, 1995.

37. Elizabeth Padjen, "Preserving New England's Cultural Landscape," *Art New England,* April/May 1996.

38. Alan Gussow, *The Artist as Native: Reinventing Regionalism,* Pomegranate Artbooks, San Francisco, 1993. A recent issue of the *Boston Globe Magazine* declared the Northeast Kingdom where Utiger lives in Vermont to be "New England's Last Frontier."

39. Christine Benvenuto, "Landscapes minus the debris of modern life," *Amherst Bulletin,* June 17, 1994.

40. Henry Beston, *The Outermost House: A Year of Life on the Great Beach of Cape Cod,* New York, The Viking Press, 1928.

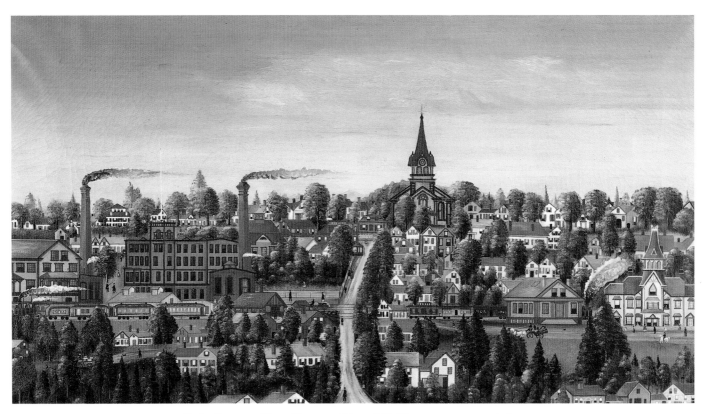

G. J. GRIFFIN, View of Freeport, Maine, 1886, Oil on canvas, 21 x 39 inches

IN EVERY CORNER OF THIS NEW ENGLAND COUNTRY,

where the ways of the eighteenth century lingered on, a fresh and more vigorous spirit was plainly astir. . . .
Life was filled with a kind of electric excitement. The air resounded with the saw and hammer, the blows of
the forge, the bells in the factory-towers. . . . Dwellings were going up in clearings and meadows. . . .
Churches grew like snowdrops in early March. Villages, towns sprang from the fields. A current of ambition
had galvanized New England. The "era of good feeling" was on its way.

VAN WYCK BROOKS, *The Flowering of New England, 1815–1865*

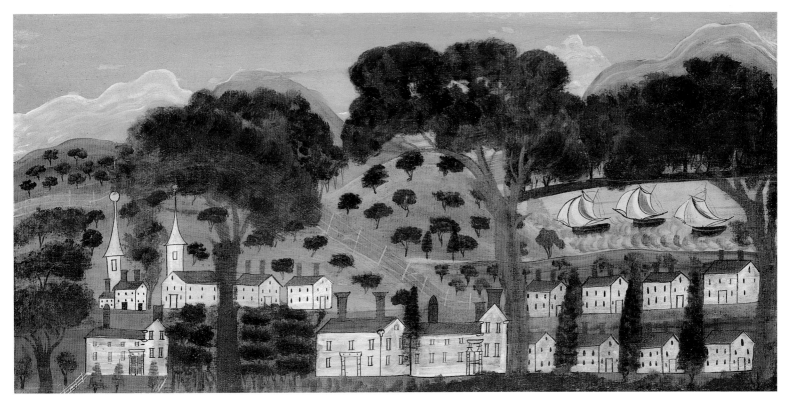

ANONYMOUS, New England Village, early 19th century, Oil on wood, 12 3/8 x 25 9/16 inches

THE MAN WHO LOVES NEW ENGLAND,
and particularly the spare region of Connecticut, loves it precisely
because of the spare colors, the thin light, the delicacy and slightness
and beauty of the place.

WALLACE STEVENS, *Connecticut*

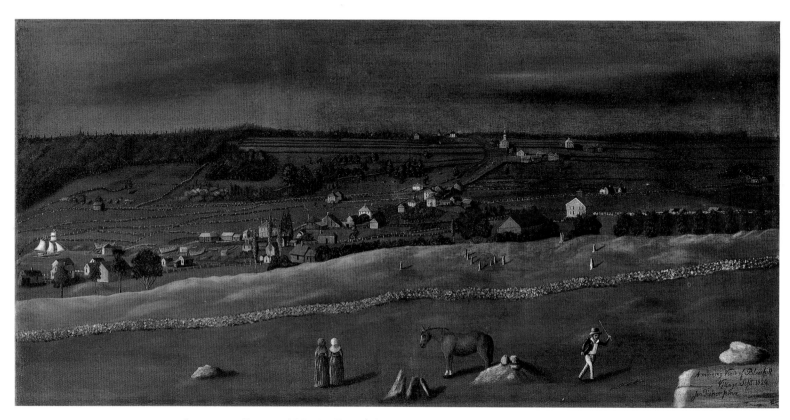

JONATHAN FISHER, A Morning View of Blue Hill Village, 1824, Oil on canvas, 25 5/8 x 52 1/4 inches

I THINK IT PROBABLE THAT FOR THE PRESENT I SHALL WORK ON THE FARM

and at mechanics, and preach now and then a Sabbath and a lecture in Bluehill and vicinity... As respects my temporal concerns, I may remark that I have at present a competency. I owe but little, and I have about $200 due to me. I raised this year about 50 bushels of potatoes, some other sauce, such as beets, beans, and peas, and probably 5 bushels of wheat. The crops of wheat, barley, and oats in Maine this summer have been very good. This is a great mercy. Oh, if the fruits of righteousness were as abundant, we should be a happy State.

JONATHAN FISHER, Letter to his children, November, 1837

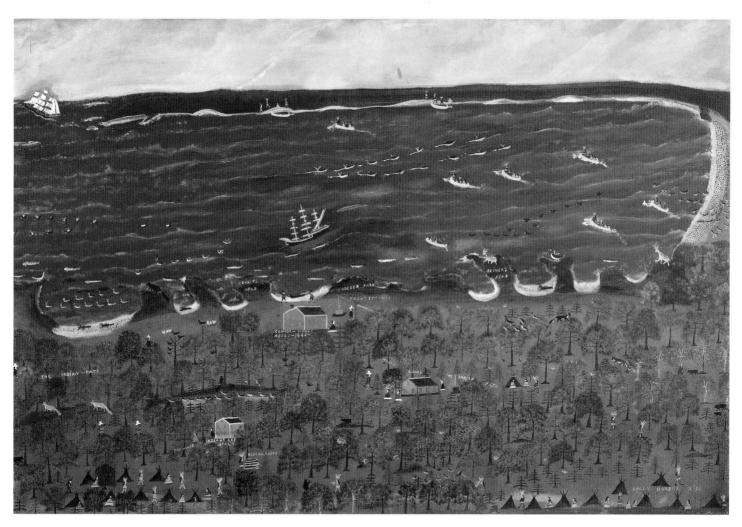

JOHN ORNE JOHNSON FROST, Indian Encampment at Salem Harbor Side, c. 1920s, Oil on beaver board, 47 1/2 x 70 1/2 inches

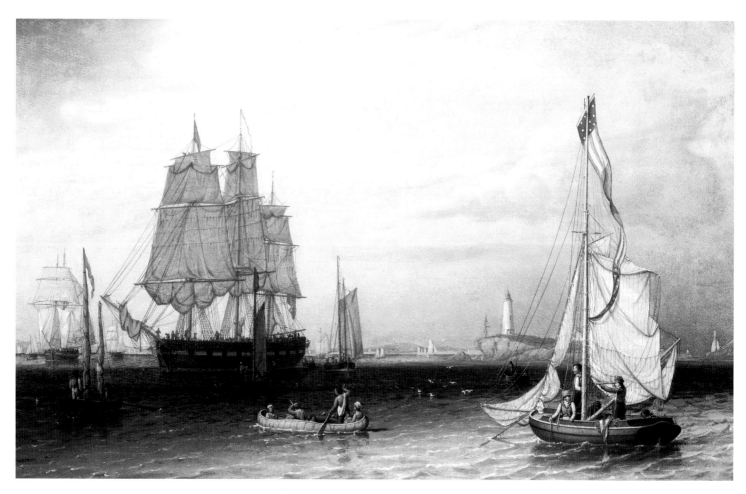

ROBERT SALMON, Shipping Off Boston Light, c. 1830, Oil on panel, 16 x 24 inches

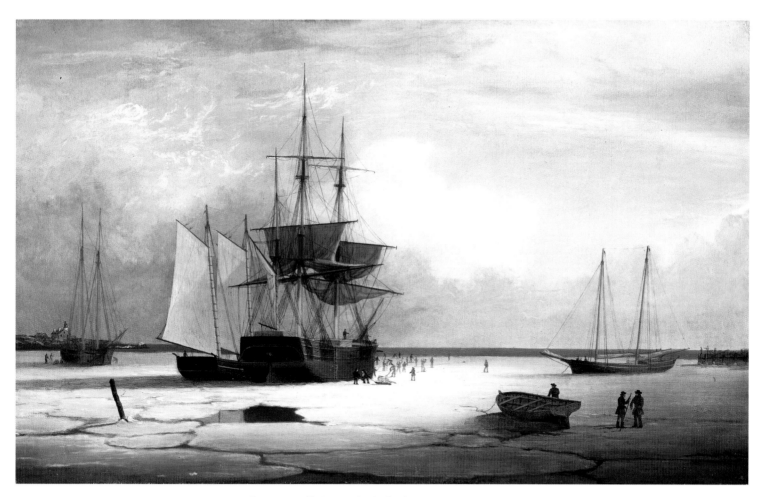

FITZ HUGH LANE, Ships in Ice off Ten Pound Island, Gloucester, 1850s, Oil on canvas, 12 x 19 3/4 inches

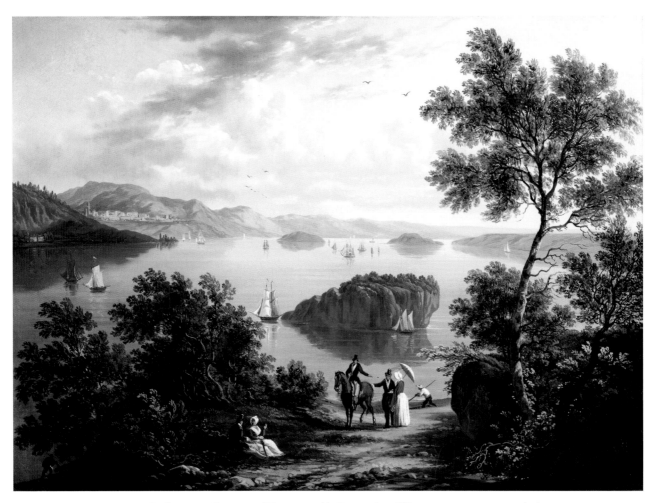

VICTOR DeGRAILLY, Eastport and Passamaquoddy Bay, c. 1840, Oil on canvas, 17 1/4 x 23 1/2 inches

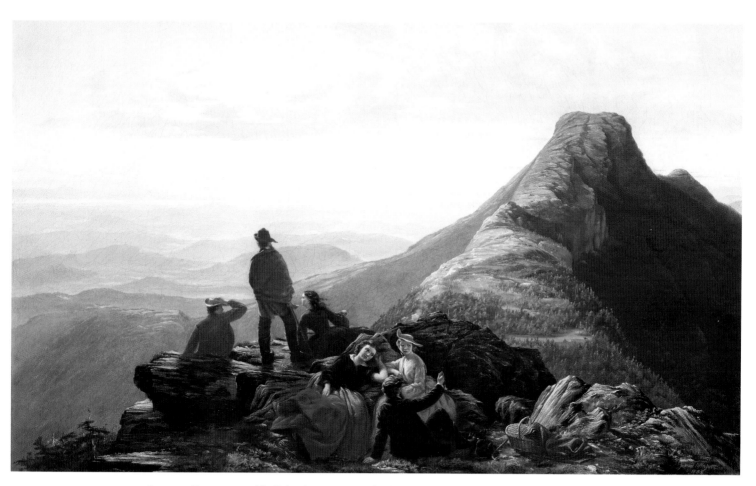

JEROME THOMPSON, The Belated Party on Mansfield Mountain, 1858, Oil on canvas, 38 x 63 1/8 inches

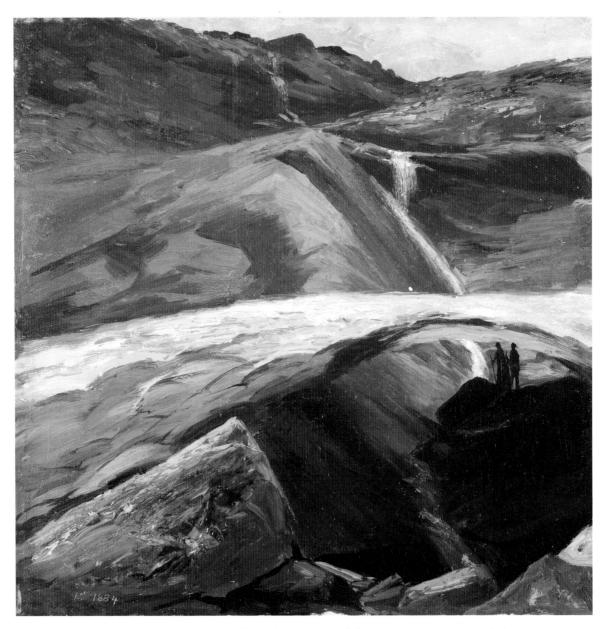

EDWARD HILL, Snow Arch at Tuckerman's Ravine, 1884, Oil on canvas, 14 15/16 x 15 3/16 inches

THE MOUNTAINS

are more grand and inspiring when we stand
at the proper distance and look at them, than
when we look from them. Their highest call is
to be resting-places of the light, the staffs from
which the most gorgeous banners of morning
and evening are displayed. And these uses we
may observe and enjoy among the moderate
mountains of New Hampshire. They are huge
lay figures on which Nature shows off the
splendors of her aerial wardrobe.

REVEREND T. STARR KING,
*The White Hills; Their Legends, Landscape,
and Poetry,* 1860.

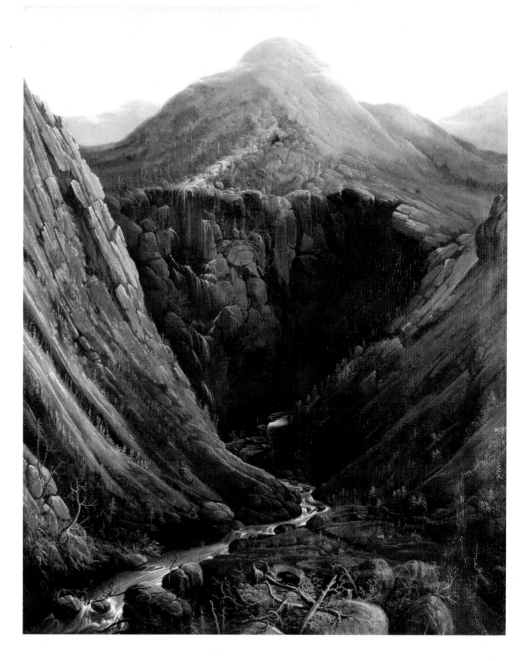

CHARLES OCTAVIUS COLE, Imperial Knob and
Gorge: White Mountains of New Hampshire, 1853,
Oil on canvas, 44 7/8 x 36 1/8 inches

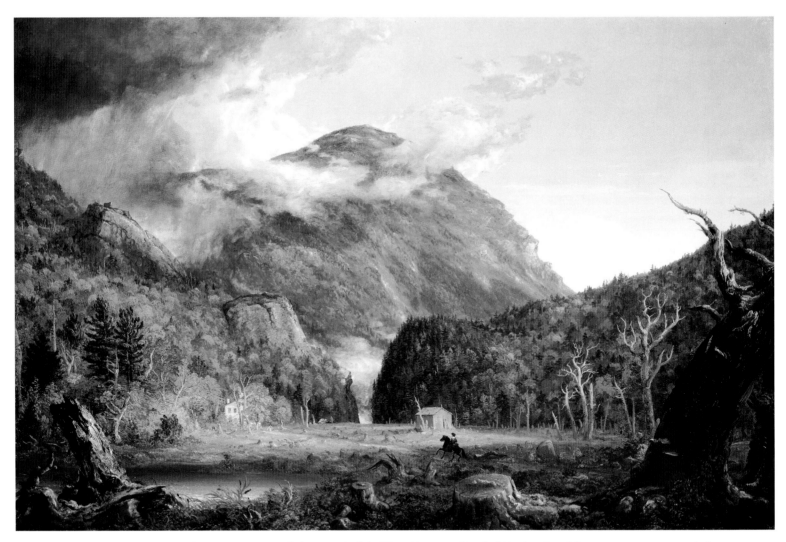

THOMAS COLE, A View of the Mountain Pass Called the Notch of the White Mountains (Crawford Notch), 1839, Oil on canvas, 53 1/2 x 74 5/8 inches

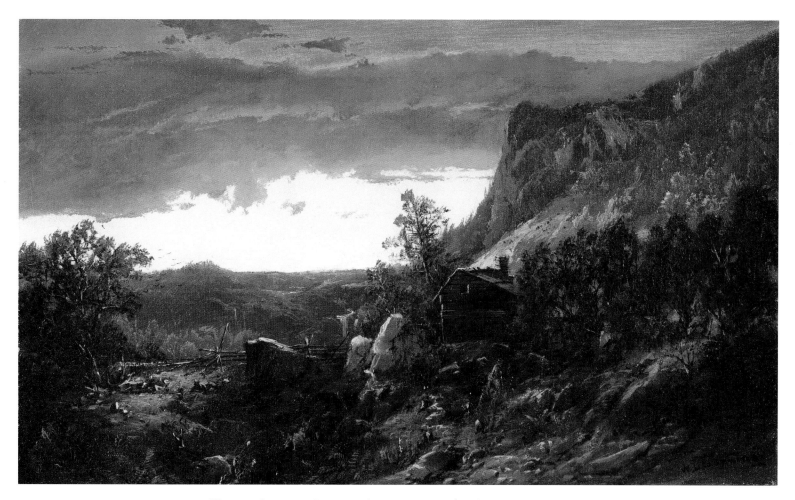

WILLIAM SONNTAG, Evening in the Mountains, c. 1863, Oil on canvas, 12 x 20 inches

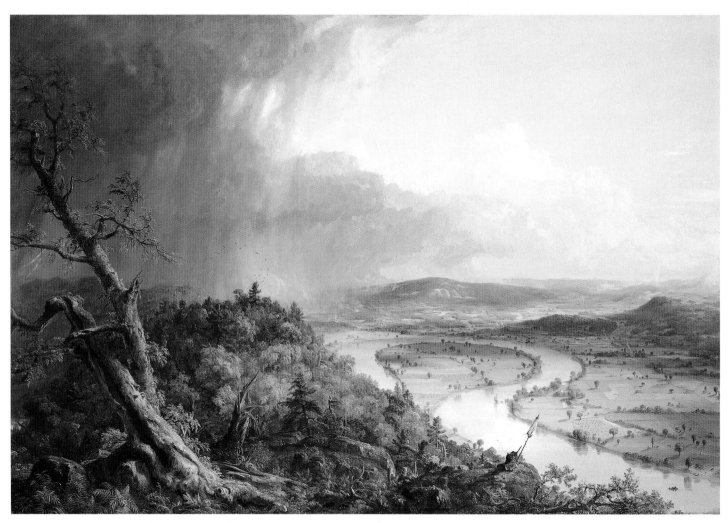

THOMAS COLE, View from Mount Holyoke, Northampton, Massachusetts, after a Thunderstorm—The Oxbow, 1836, Oil on canvas, 51 1/2 x 76 inches

IN THE CONNECTICUT WE BEHOLD A RIVER

which differs widely from the Hudson. Its sources are amid the wild mountains of New Hampshire; but it soon breaks into a luxuriant valley, and flows for more than a hundred miles. . . Whether we see it at

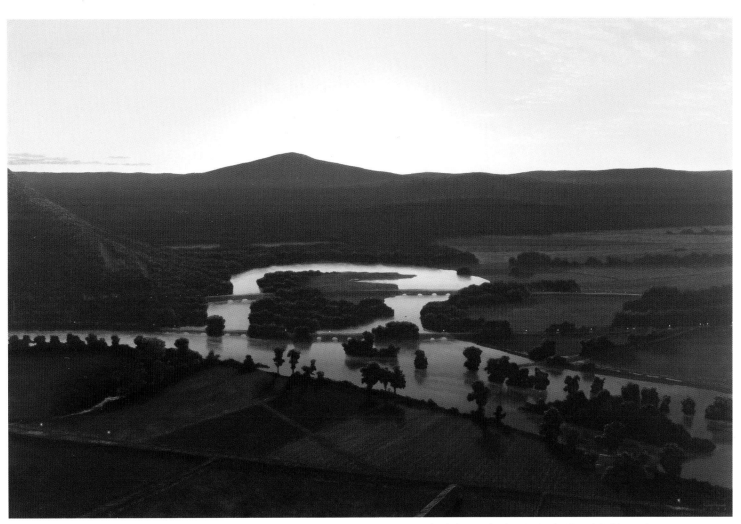

STEPHEN HANNOCK, *The Oxbow, After Church, After Cole, Flooded 1979–1994 (Flooded River for the Matriarchs: E. and A. Mongan), 1994,*
Polished oil on canvas, 54 x 81 inches

Haverhill, Northampton, or Hartford, it still possesses that gentle aspect;
and the imagination can scarcely conceive Arcadian vales more lovely or
more peaceful than the valley of the Connecticut....

THOMAS COLE, *Essay on American Scenery,* 1836

FREDERIC EDWIN CHURCH, West Rock, New Haven, 1849, Oil on canvas, 26 1/2 x 40 inches

MARTIN JOHNSON HEADE, Newburyport Marshes: Passing Storm, c. 1865–70, Oil on canvas, 15 x 30 inches *(opposite)*

BOYS ARE WILD ANIMALS, RICH IN THE TREASURES OF SENSE,
but the New England boy had a wider range of emotions than boys of more equable climates.
He felt his nature crudely, as it was meant. To the boy Henry Adams, summer was drunken.
Among senses, smell was the strongest—smell of hot pine-woods and sweet-fern in the scorching
summer noon; of new-mown hay; of ploughed earth; of box hedges; of peaches, lilacs, syringas; of
stables, barns, cow-yards; of salt water and low tide on the marshes, nothing came amiss.

HENRY ADAMS, *The Education of Henry Adams,* 1918

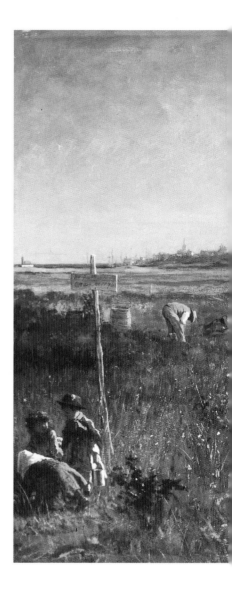

I WAS TAKEN WITH MY CRANBERRY FIT AS SOON AS I ARRIVED
(some people have Rose fever yearly—I have the cranberry fever) as they began picking down on the
meadow a day or two after we arrived and I have done nothing else since I have been here, not a
thing, but if I dare to show you it you may help me maybe, or maybe complete my despair. I have
no finished picture at all, maybe further off than ever.

Eastman Johnson, Letter to Jervis McEntee, 1879

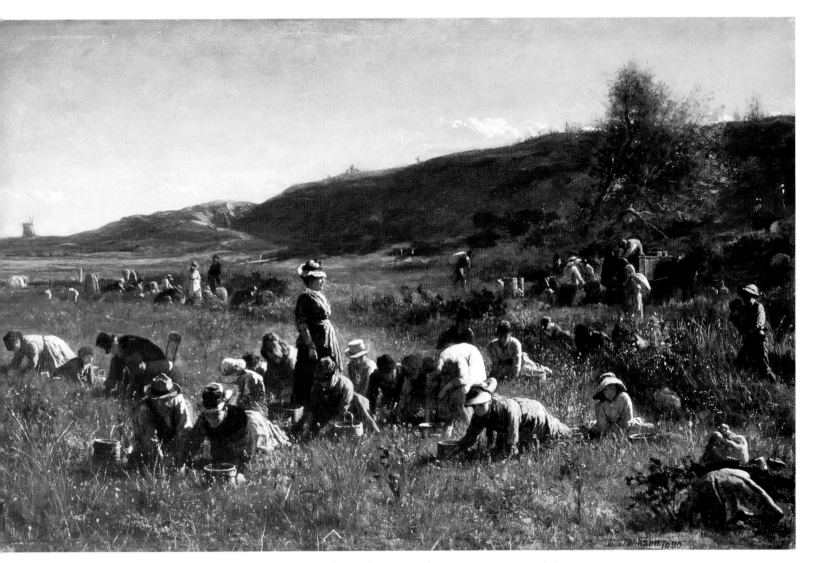

EASTMAN JOHNSON, The Cranberry Harvest, Island of Nantucket, 1880, Oil on canvas, 27 1/2 x 54 5/8 inches

A THOUSAND DELICATE PLACES,

dear to the distinterested rambler, small mild "points" and promontories, far away little lonely, sandy coves, rock-set, lily-sheeted ponds, almost hidden, and shallow Arcadian summer-haunted valleys, with the sea just over some stony shoulder: a whole world with its scale so measured and intended and happy, its detail so finished and pencilled and stippled (certainly for American detail!) that there comes back to me, across many years, no better analogy for it than that of some fine foreground in an old "line" engraving.

HENRY JAMES, *The Sense of Newport*, 1907

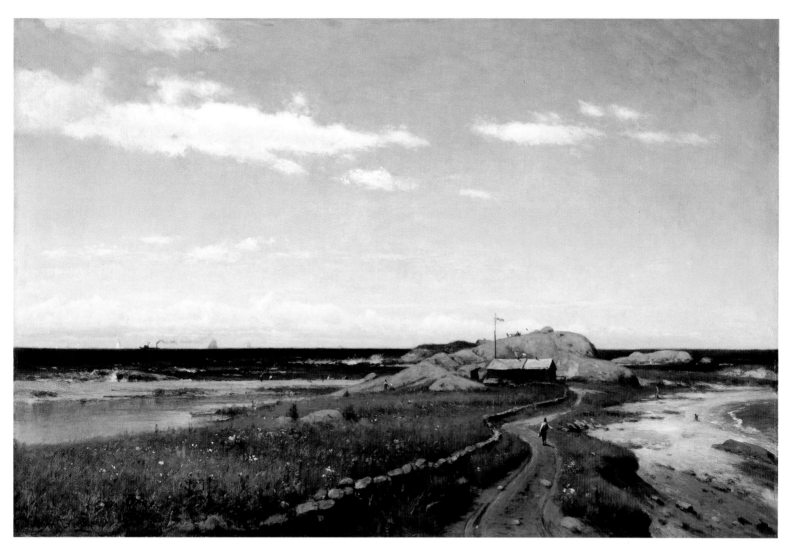

WORTHINGTON WHITTREDGE, A Breezy Day—Sakonnet Point, Rhode Island, c. 1880, Oil on canvas, 25 3/8 x 38 1/2 inches

JOHN FREDERICK KENSETT, Almy Pond, Newport, 1855–1859, Oil on canvas, 12 5/8 x 22 1/8 inches *(opposite)* 47

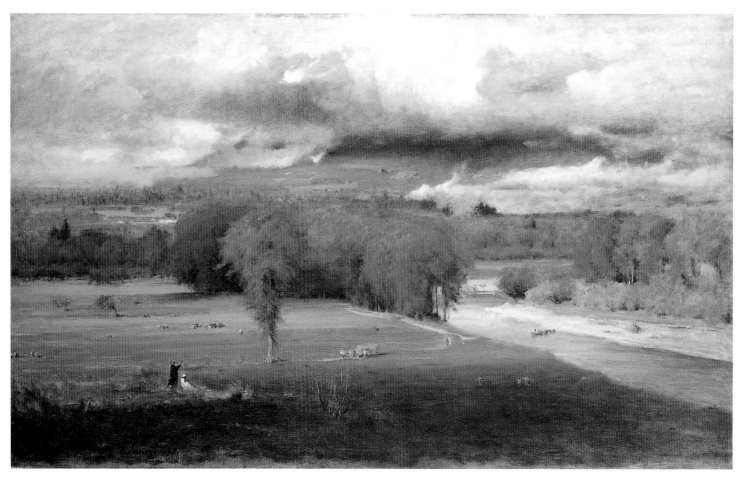

GEORGE INNESS, *Saco Ford: Conway Meadows*, 1876, Oil on canvas, 38 x 63 inches

. . . THE HIGHEST ART IS WHERE HAS BEEN MOST PERFECTLY BREATHED the sentiment of humanity. Rivers, streams, the rippling brook, the hillside, the sky, the clouds—all things that we see—can convey that sentiment if we are in the love of God and the desire of truth.

48 GEORGE INNESS, 1878

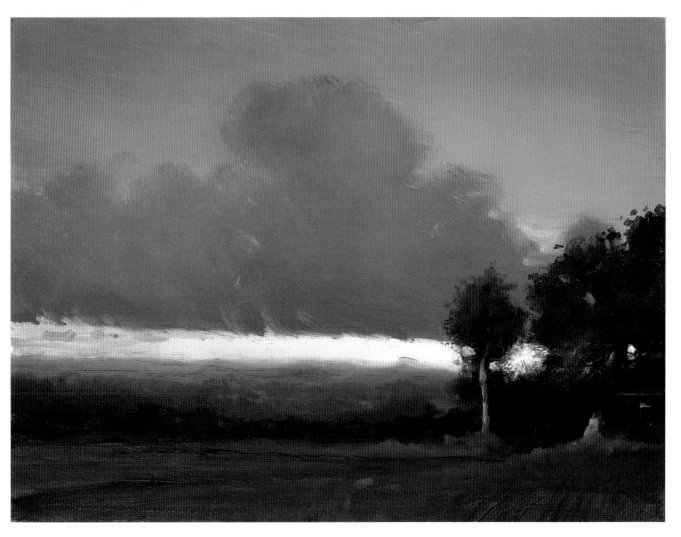

F R A N K M A S O N , Peacham Sunset, Vermont, 1986, Oil on panel, 16 x 12 inches

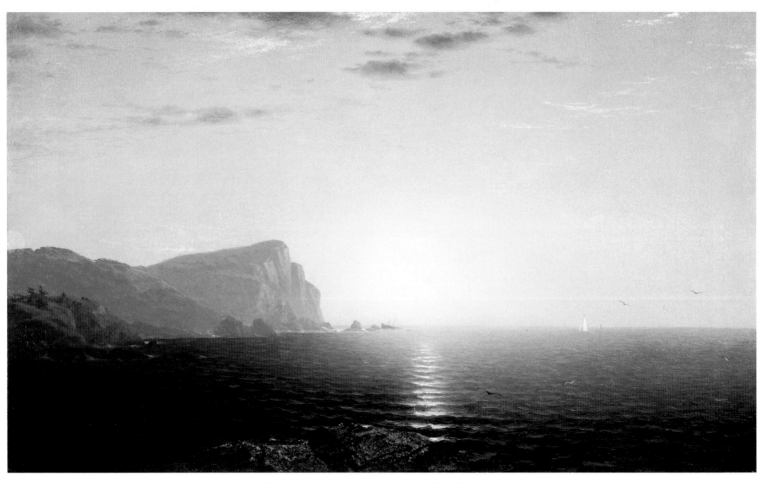

JOHN FREDERICK KENSETT, New England Sunrise, c. 1863, Oil on canvas, 18 x 30 1/4 inches

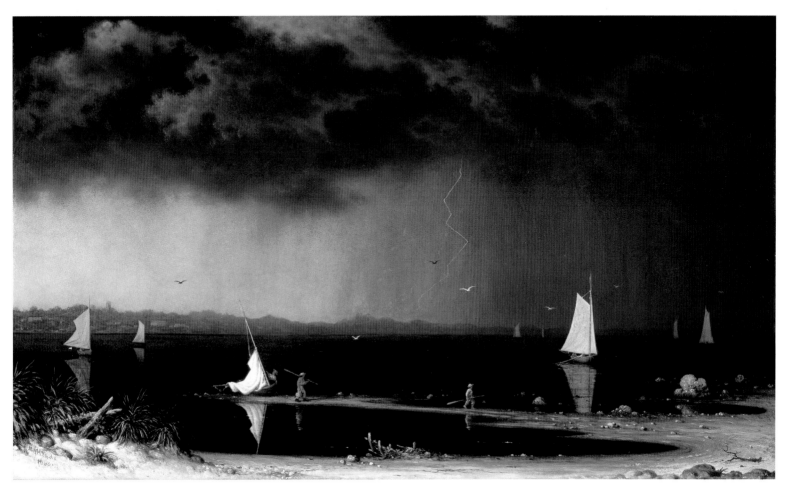

MARTIN JOHNSON HEADE, Thunderstorm On Narragansett Bay, 1868, Oil on canvas, 32 1/8 x 54 1/2 inches

NEW ENGLAND HAS A HARSH CLIMATE,

a barren soil, a rough and stormy coast, and yet we love it, even with a love
passing that of dwellers in more favored regions.

HENRY CABOT LODGE

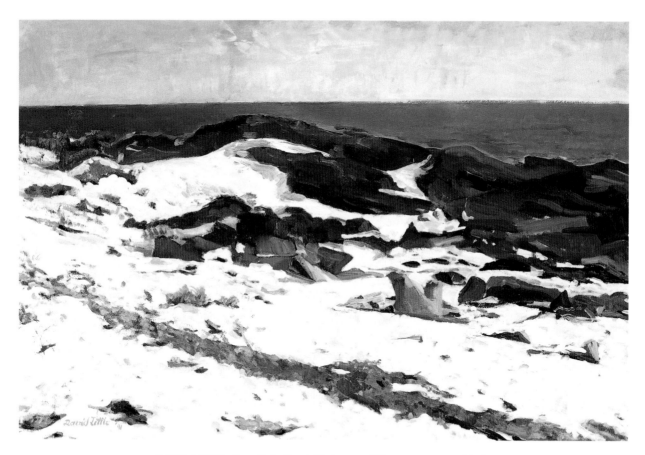

DAVID LITTLE, Shore Path, Prout's Neck, 1991, Oil on canvas, 24 x 36 inches

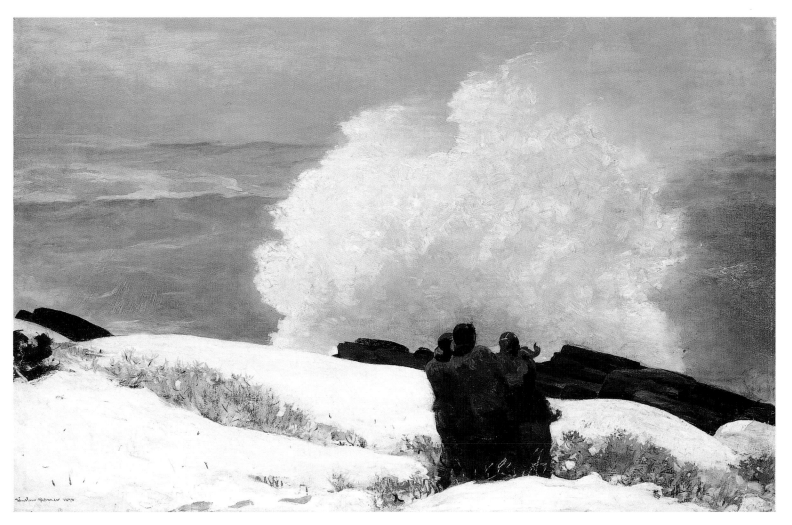

WINSLOW HOMER, Watching the Breakers—A High Sea, 1896, Oil on canvas, 24 x 38 inches

JOSEPH DECAMP, Seascape, 1911, Oil on canvas, 25 x 30 inches

BEATRICE WHITNEY VAN NESS, Whitecaps, c. 1926, Oil on canvas, 18 x 22 inches

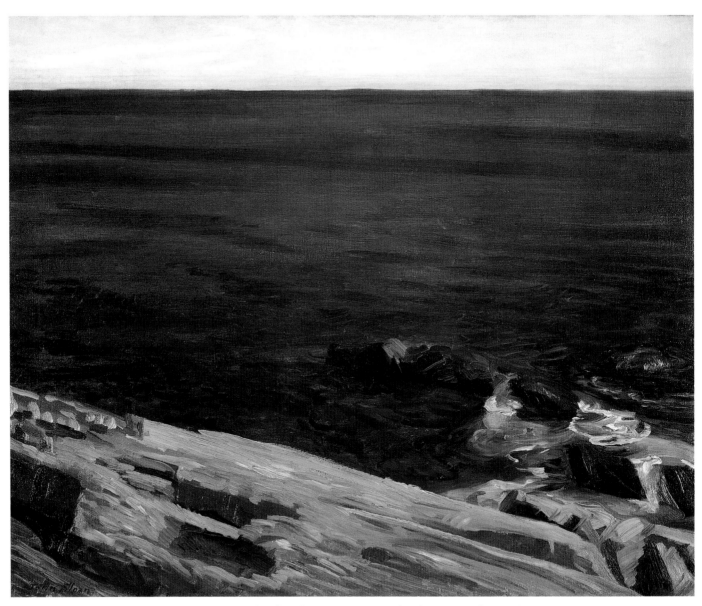

JOHN SLOAN, Red Rocks and Quiet Sea No. 2, 1916, Oil on canvas, 26 x 32 inches

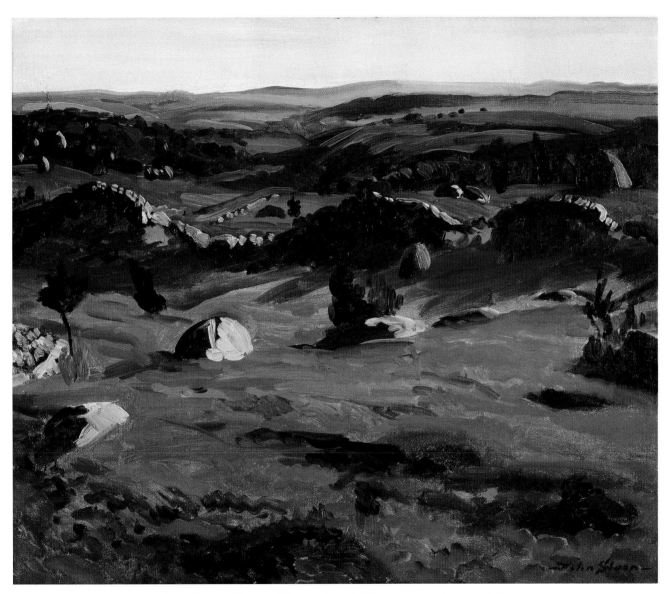

JOHN SLOAN, Dogtown (Gloucester), 1916, Oil on canvas, 20 1/4 x 24 1/4 inches

JOHN HENRY TWACHTMAN, End of Winter, after 1889, Oil on canvas, 22 x 30 1/8 inches

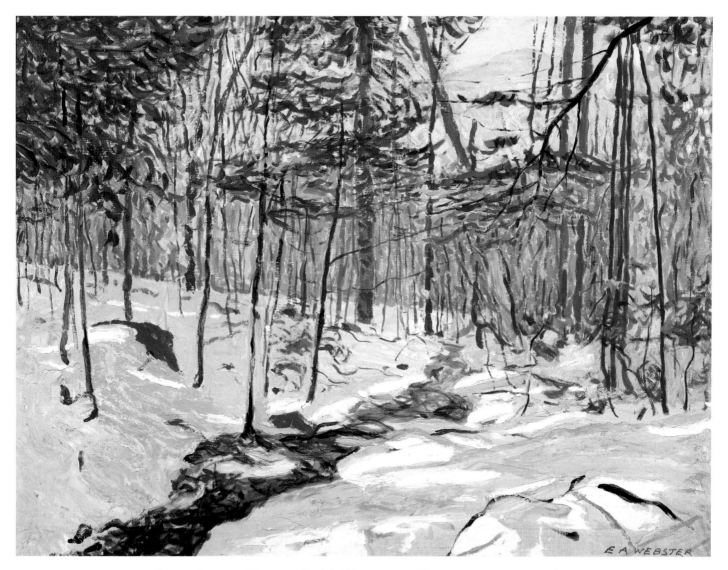

EDWIN AMBROSE WEBSTER, Brook in Winter, c. 1914, Oil on canvas, 29 1/2 x 39 1/2 inches

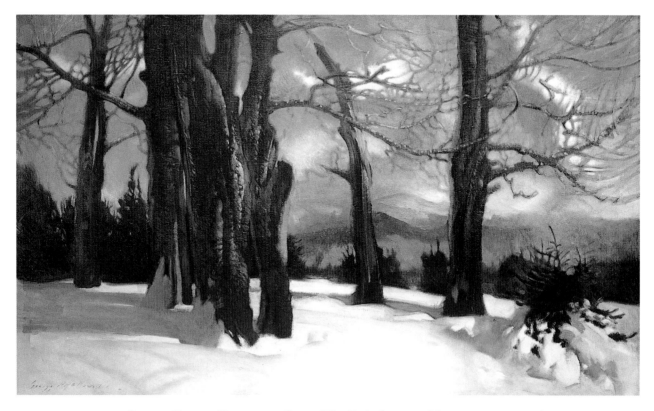

GEORGE HAWLEY HALLOWELL, *Crown of New England*, c. 1905, Oil on canvas, 28 x 47 inches

BLACK trees against a marble hill
Of January snow declare
New England to whoever will
Behold them darkly standing there.

Despoiled of leaves, uncheered by sun
Save now and then a grudging dole,
They stand like berserks every one,
Denied the berserks' wassail bowl.

On days less friendly to the dark,
Chastened, they climb the little rise,
And lift slim hands in prayer to mark
Their kinship with ascetic skies—

A kinship whose serene repose
On mornings after snow has blown
Dwells deepest on the branch that throws
Blue shadows over walls of stone.

WILBERT SNOW, *Hillside Trees*

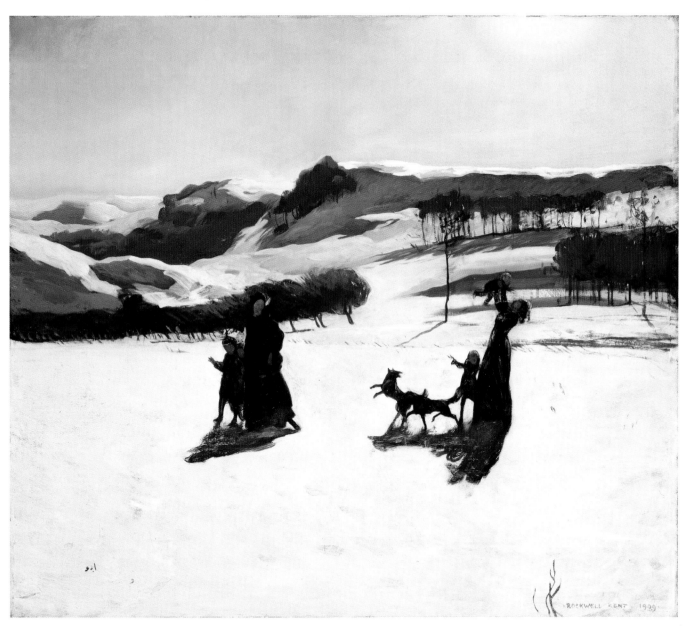

ROCKWELL KENT, Snow Fields (Winter in the Berkshires), 1909, Oil on canvas, 38 x 44 inches

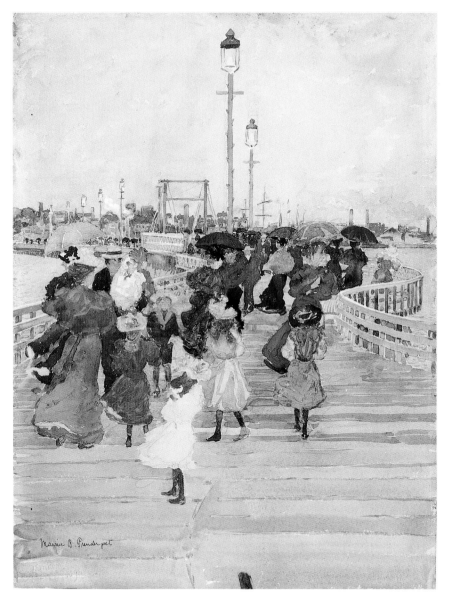

MAURICE PRENDERGAST, South Boston Pier, 1896, Watercolor over graphite, 18 1/8 x 13 5/16 inches

THE fall spirit over these coast towns,
As thick as the myriad leaves
At the foot of her oaks or red maples,
Stirs with a mood as much different from summer's
As the sigh of the wind in November branches
From the rippling of zephyrs through leaves of July.
Men return, catlike, again to these harbors
To be crooned to in age by the voice of the sea;
And the kelps and the rockweed, the old mother's jewels,
Though tinted four seasons an iodine brown,
Only reach to the height of their crystalline luster
When the October sun sluices off the gold nuggets
Of a thousand red cliffs in a clean-up of beauty.

WILBERT SNOW, *Autumn Country*

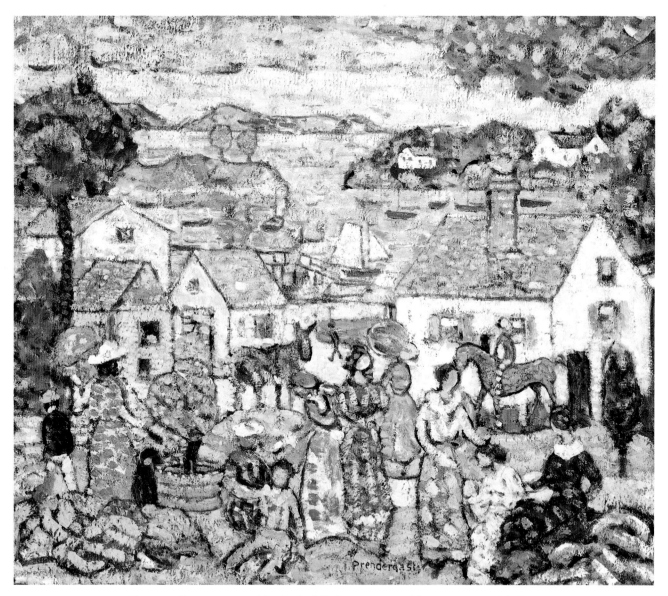

MAURICE PRENDERGAST, New England Harbor, c. 1919–23, Oil on canvas, 24 x 28 inches

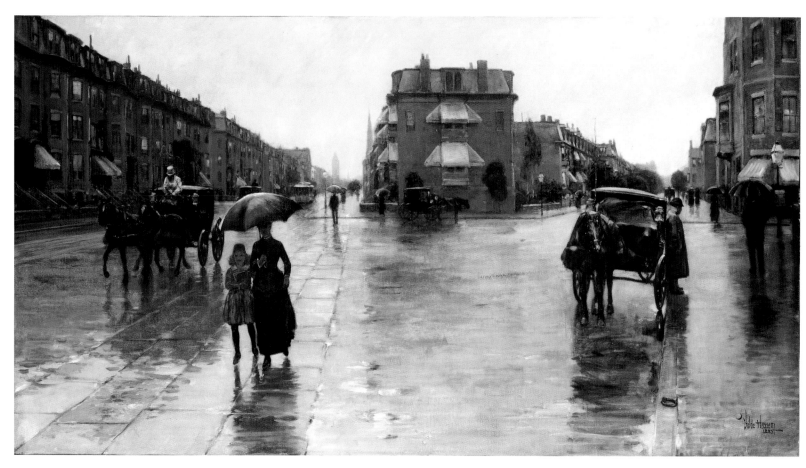

CHILDE HASSAM, Rainy Day, Boston, 1885, Oil on canvas, 26 1/8 x 48 inches

WILLIAM WALLACE GILCHRIST, Congress Square in Winter, c. 1915, Oil on canvas, 20 x 26 inches

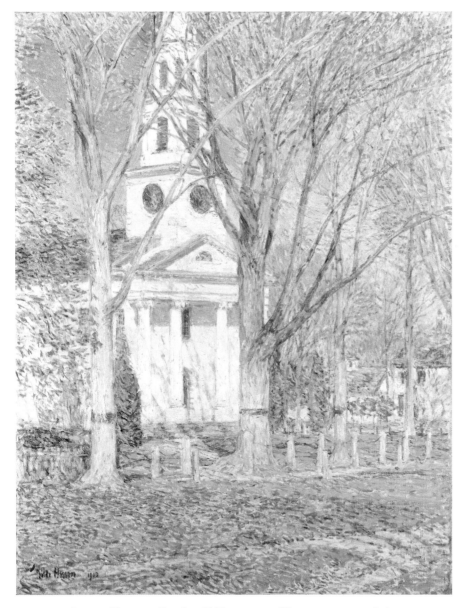

I AM OFTEN ASKED
what determines my selection of subjects, what makes me
lean toward impressionism. I do not know. I can only paint
as I do and be myself, and I would rather be myself and
work out my ideas, my vagaries, if you please, in color,
than turn out Christmas cards and have to hire a clerk to
attend to orders. I am often asked why I paint with a low-
tone, delicate palette. Again I cannot tell. Subjects suggest
to me a color scheme and I just paint.

CHILDE HASSAM, Brush and Pencil 8, June 1901.

CHILDE HASSAM, Church at Old Lyme, 1903, Oil on canvas, 37 x 29 inches

WILLARD LEROY METCALF, White Lilacs, 1912, Oil on canvas, 29 x 33 inches

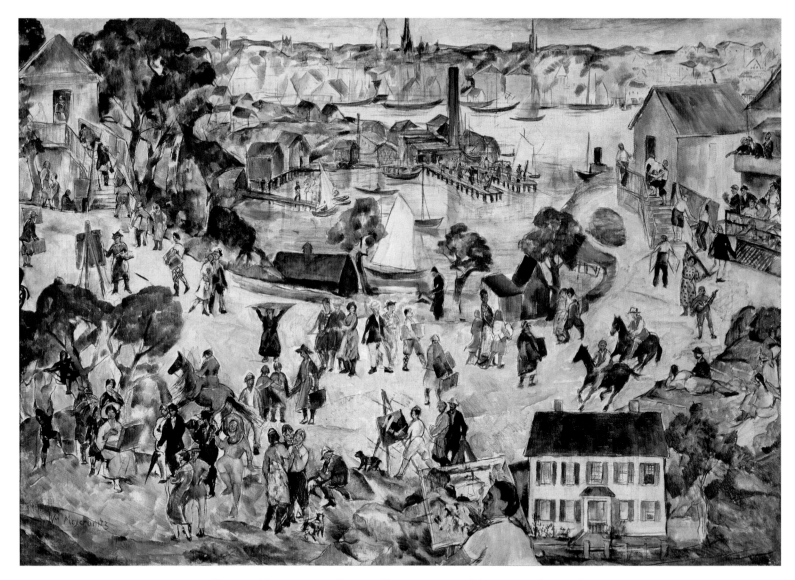

WILLIAM MEYEROWITZ, Gloucester Humoresque, 1927, Oil on canvas, 36 x 52 inches

LAUREN FORD, The Country Doctor, c. 1935, Oil on canvas, 54 x 72 inches

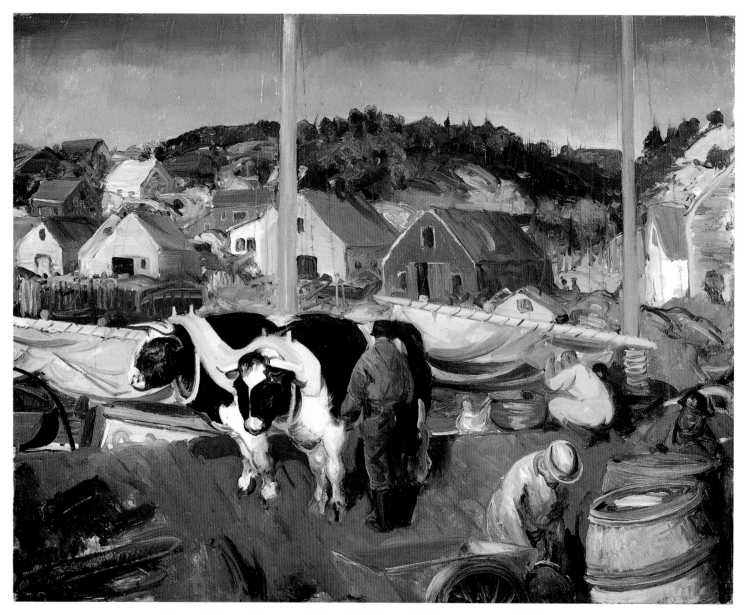

Geroge Wesley Bellows, Ox Team, Matinicus, 1916, Oil on canvas, 22 x 28 inches

J. ALDEN WEIR, Midday Rest in New England, 1897, Oil on canvas, 39 5/8 x 50 3/8 inches

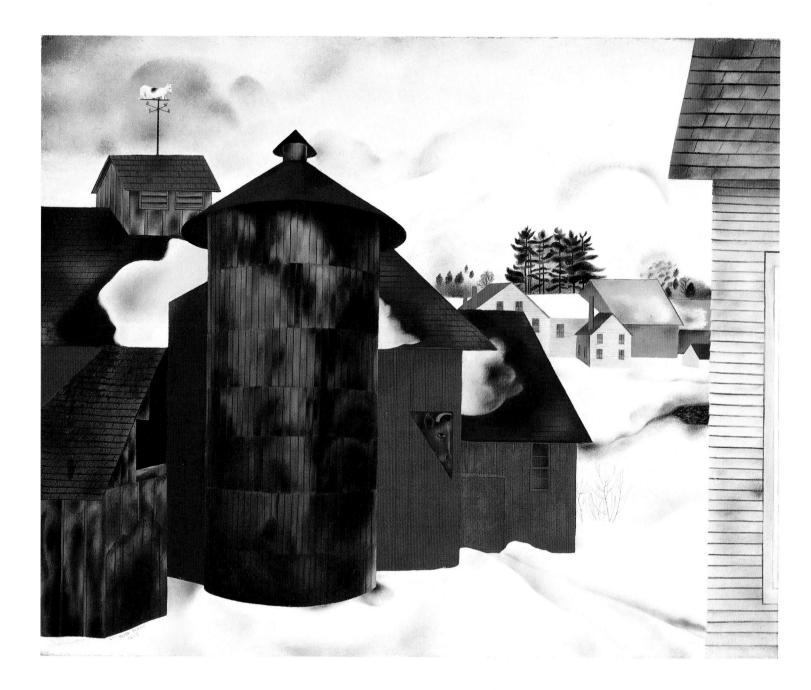

HOW many shingles has this barn been through?
How many floors? For almost two hundred years
Its square timbers and its thin patched walls
Have been standing up to the wind, have been holding off
The bitter cold, the great night of the whirling
Darkness.

Now, once again, it is that time
Of year when the cold triumphs, the night rules.
Every day the sun rises farther away.
It is hard to imagine him halting his march to the South,
Stopping a little, resting in the black whirlwind
Of space to take new form, to be born again,
In a barn.

KATE BARNES, *The Barn in December*

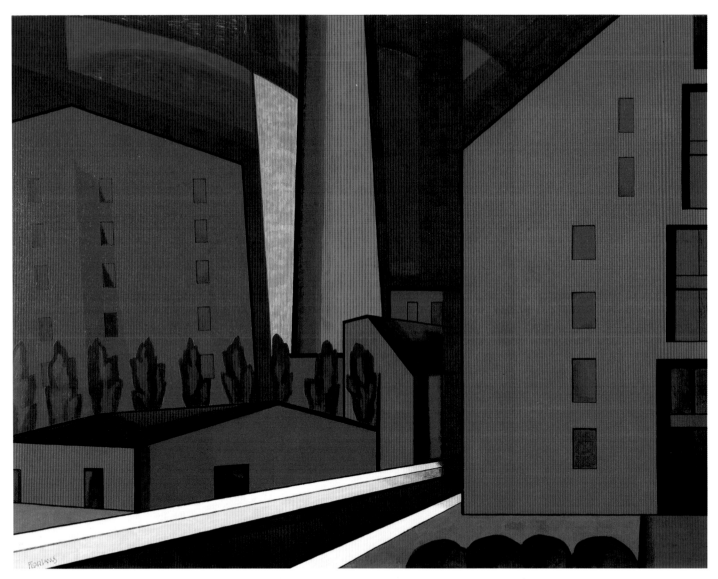

OSCAR BLUEMNER, Walls of New England, 1935, Casein varnish on insulite panel, 36 x 48 inches

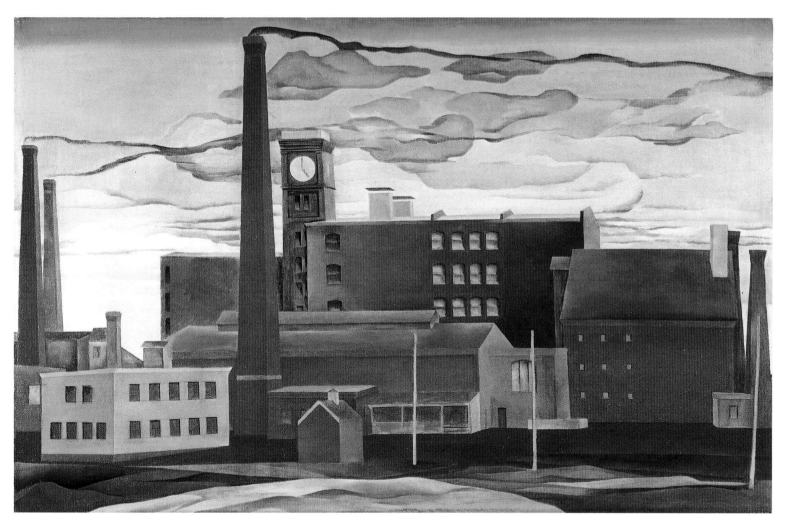

STEFAN HIRSCH, Factories, Portsmouth, New Hampshire, 1930, Oil on canvas, 17 1/4 x 27 inches

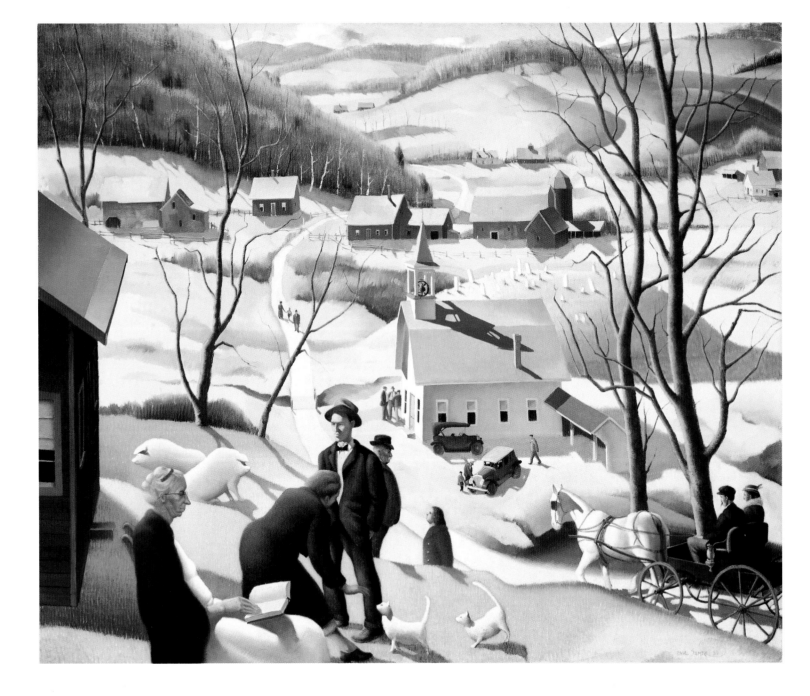

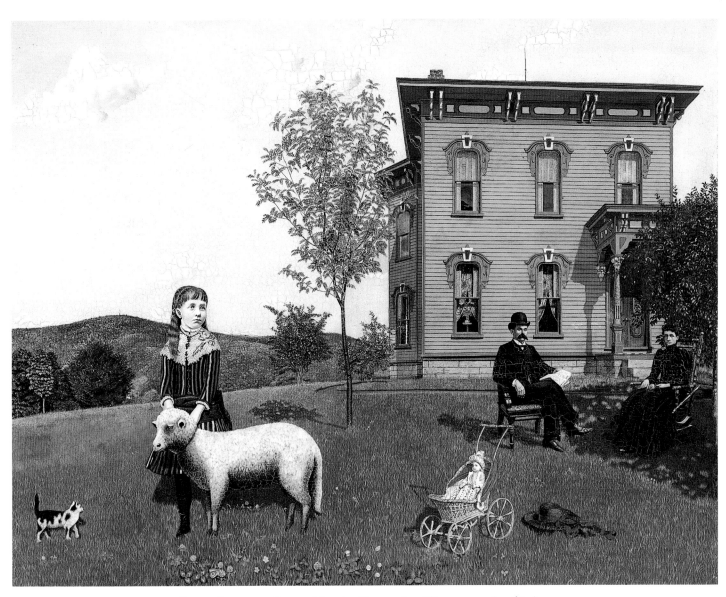

EDWIN ROMANZO ELMER, Mourning Picture, 1890, Oil on canvas, 28 x 36 inches

PAUL STARRET SAMPLE, Beaver Meadow, 1939, Oil on canvas, 40 x 48 1/4 inches *(opposite)*

Standing here [in Provincetown],

I felt as if I had not lived in vain. I was as near Europe as my legs would carry me, at the extreme of this withered arm with a town in the hollow of its hand. You seem to have invaded the domain of old Neptune, and plucked him by the very beard. For centuries the storms have beaten upon this narrow strip of sand, behind which the commerce of a State lies intrenched. The assault is unflagging, the defense obstinate. Fresh columns are always forming outside for the attack, and the roll of ocean is forever beating the charge. Yet the Cape stands fast, and will not budge. It is as if it should say, "After me the Deluge."

SAMUEL ADAMS DRAKE, *Nooks and Corners of the New England Coast,* 1875

NILES SPENCER, Back of the Town (Provincetown), 1926, Oil on canvas, 30 1/4 x 36 1/4 inches

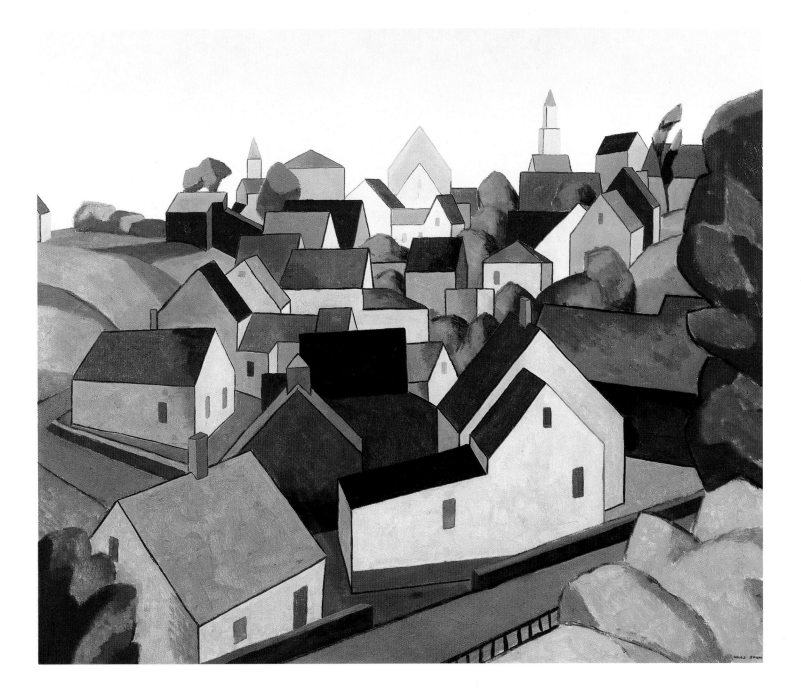

EDWIN DICKINSON, Lieutenant Island from Indian Rock, 1946, Oil on canvas, 16 x 20 inches

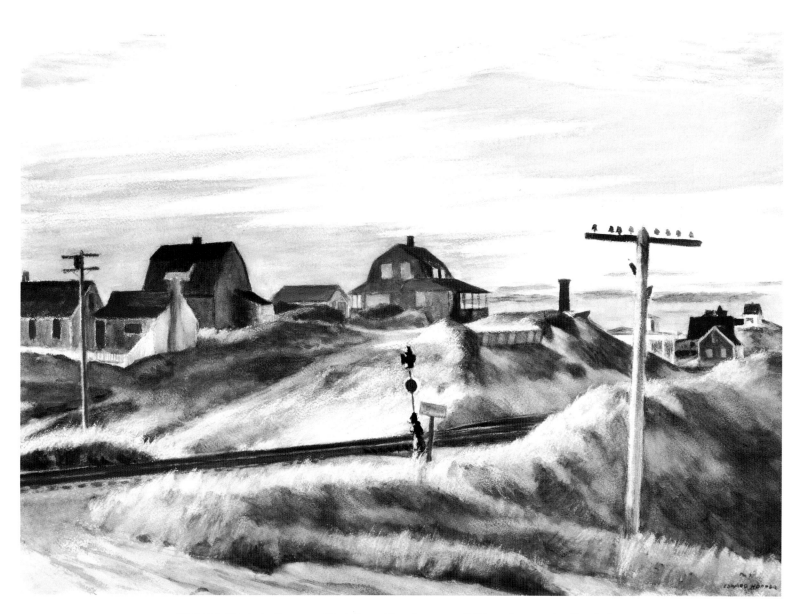

EDWARD HOPPER, Cottages at North Truro, Massachusetts, 1938, Watercolor, 20 3/16 x 28 1/8 inches

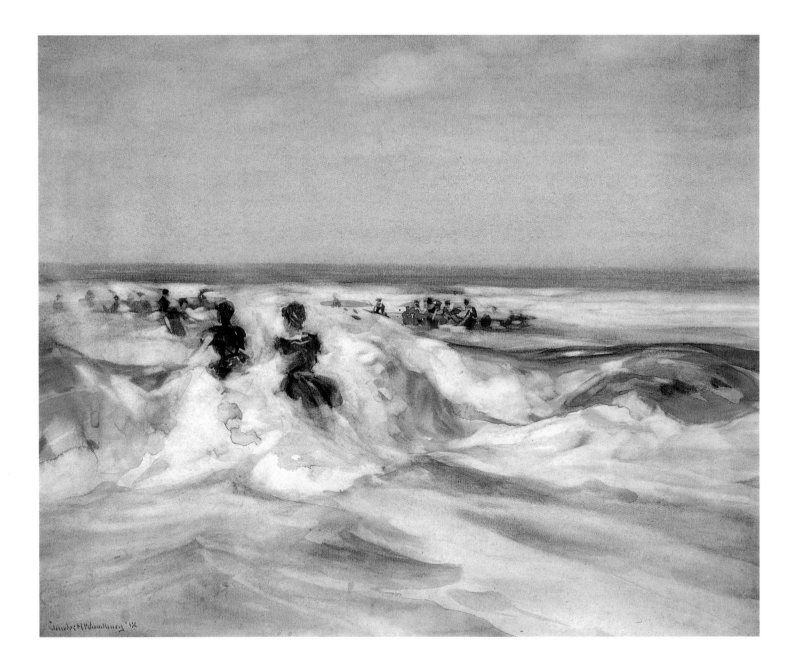

WE drove back through the hot August noon,
The motor loud, our words few and uneasy;
We had spent the morning on the wide beach,
Waiting for the slow land breeze to shift
When the tide turned.

Sprawled on the sand, we watched the swimmers take
The even waves, studied the yellow dunes
Where grass gets sustenance from salt and air;
And digging, found the rotting driftwood, shells,
A few pebbles.

The tide came to its flood. The wind veered off,
Backed to the north, and faltered, and swung east.
We reasoned this was good, and started home.
But to the west, near Boxford woods, we saw
The thunderheads.

SAMUEL FRENCH MORSE, *New England Summer*

CHARLES H. WOODBURY, In the Surf, Ogunquit, 1912, Watercolor on paper, 17 x 21 inches

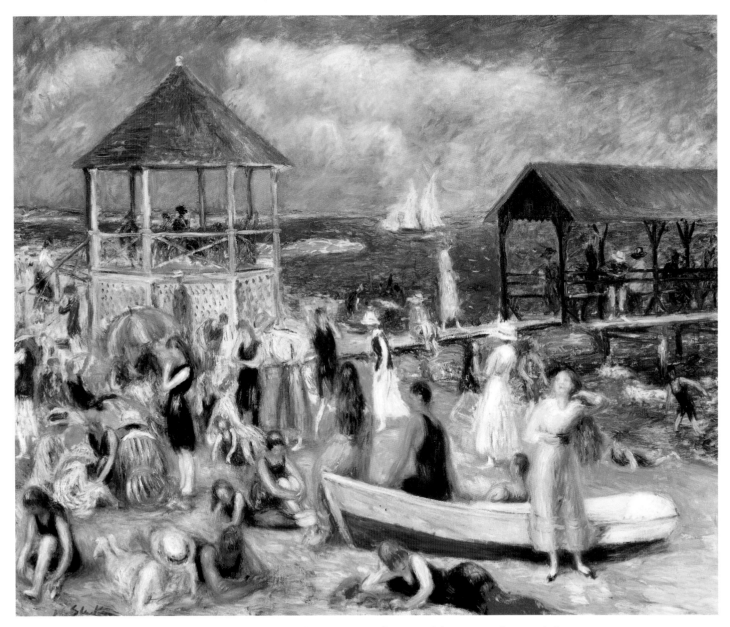

WILLIAM J. GLACKENS, Beach Scene, New London, 1918, Oil on canvas, 26 x 31 7/8 inches

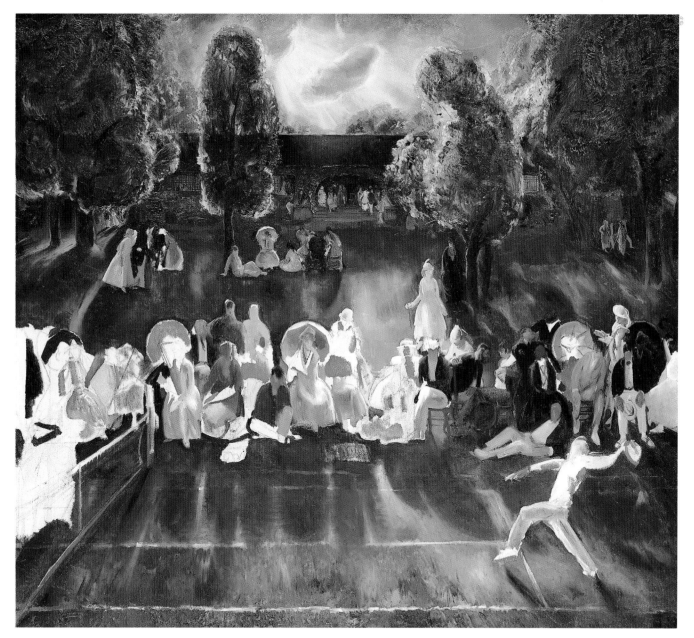

GEORGE WESLEY BELLOWS, Tennis Tournament, 1920, Oil on canvas, 59 x 66 inches

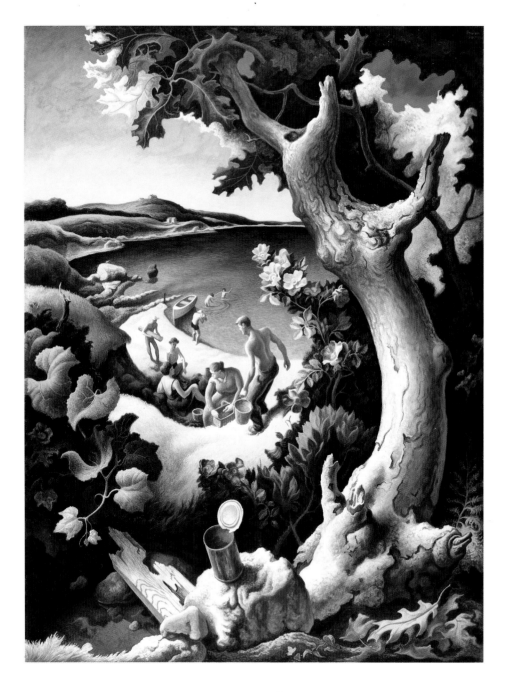

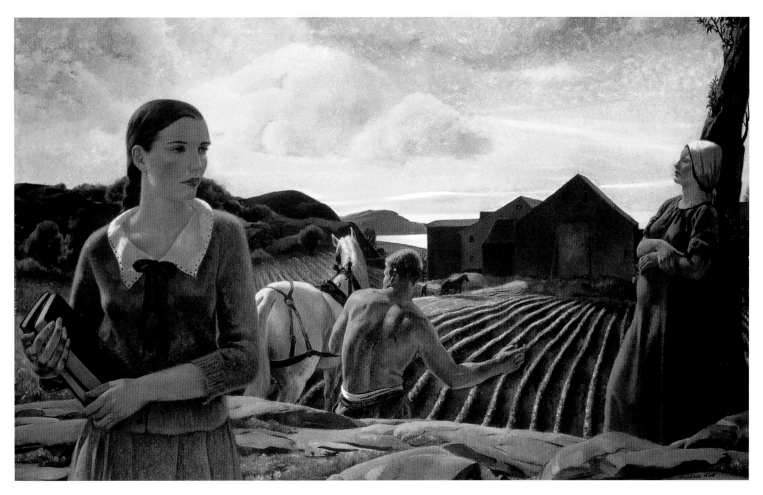

LEON KROLL, Morning on the Cape, 1935, Oil on canvas, 36 x 58 inches

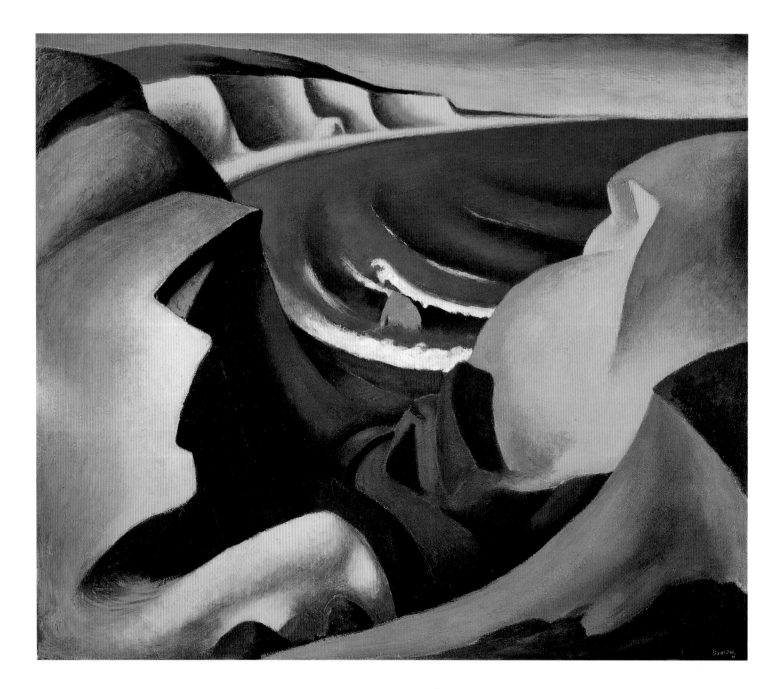

A<small>ND THEN THE COUNTRIE OF THE</small> M<small>ASSACHUSETS</small>,
which is the Paradise of all those parts. For, heere are many Iles all planted with corne,
groves, mulberries, salvage gardens, and good harbours; the Coast is for the most part, high
clayie sandie cliffs. The Sea Coast as you passe, shewes you all along large corne fields, and
great troupes of well proportioned people.

C<small>APTAIN</small> J<small>OHN</small> S<small>MITH</small>, *A Description of New England,* 1616

T<small>HOMAS</small> H<small>ART</small> B<small>ENTON</small>, The Cliffs, 1921, Oil on canvas, 29 x 34 5/8 inches

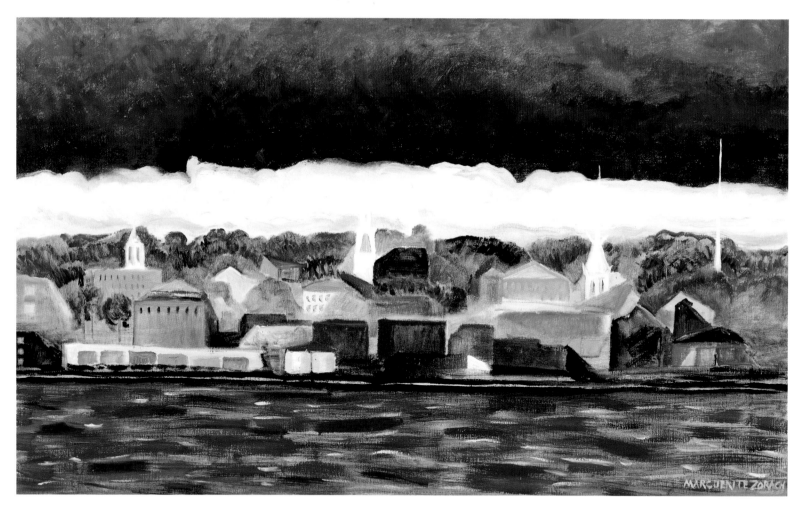

MARGUERITE ZORACH, City of Bath, c. 1927, Oil on canvas, 18 x 30 inches

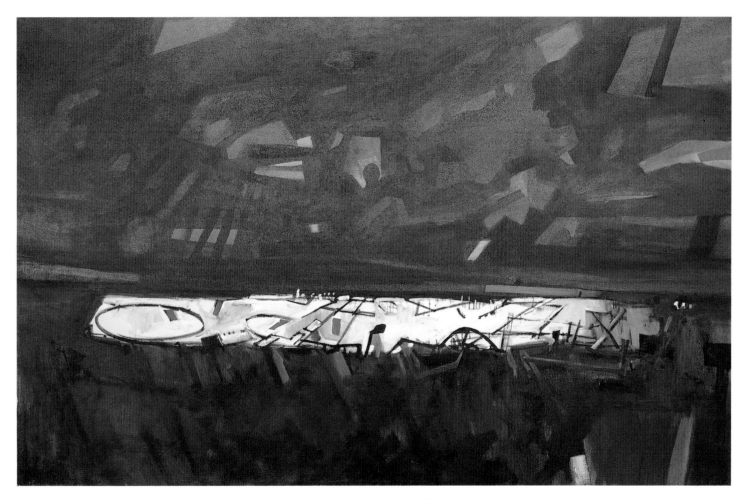

JOHN HULTBERG, Daybreak Over Island, 1962, Oil on canvas, 48 x 76 inches

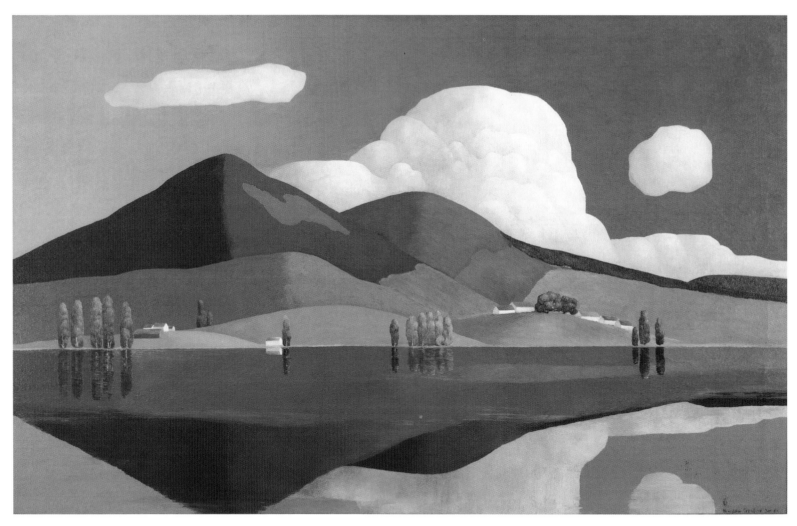

HOUGHTON CRANFORD SMITH, Reflections, Shadow Lake, Glover, Vermont, c. 1940, Oil on canvas, 33 x 53 inches

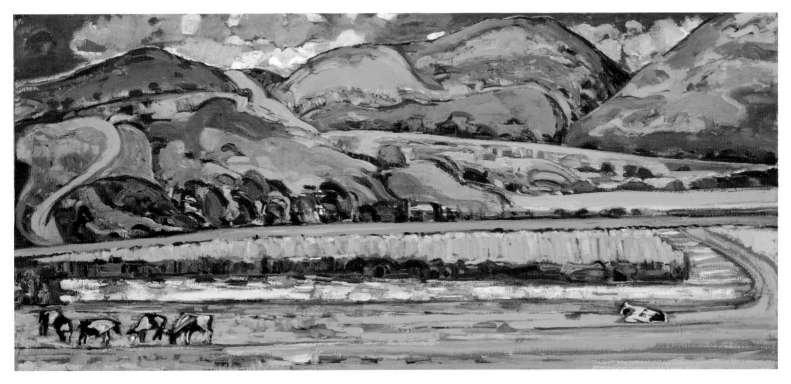

BERNARD CHAET, *Vermont Yellows*, 1991, Oil on canvas, 18 x 40 inches

THIS is your country, indolent and bright,
Where summer is a tithe of yellow days
As beautiful for your unstinting praise
As the sweet air that fills them to their height,
Dazzling the whole wide landscape golden white
Till motion is dissolved in shafted haze
Too unsubstantial for the mind's slow gaze
To understand or measure, like the light.

But the light decays and changes. All too soon
The landscape alters where the day recedes,
Still clear and fine. With darkness in your eyes
You right yourself, and see without surprise
The ditches rank with goldenrod and weeds
On a hot, dusty summer afternoon.

SAMUEL FRENCH MORSE, *The Northern Summer*

THE GREEN TREES ON THE LOVELY MOUNTAINS

that run through the middle of Vermont gave the state its name. The early French settlers called the area verdmont (green mountain); English settlers simply dropped the "d." In this instance, calling a state a mountain was only a mild hyperbole; Vermont has less level ground than almost any other state in the Union. Its people like to claim that if Vermont were stamped flat, it would be bigger than Texas.

JOE MCCARTHY, *New England*

MILTON AVERY, Vermont Hills, 1936, Oil on canvas, 32 x 48 inches

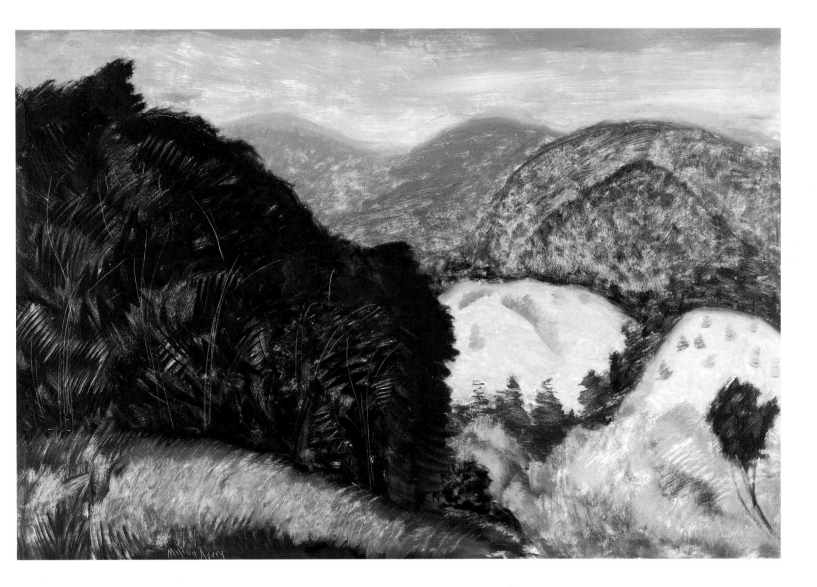

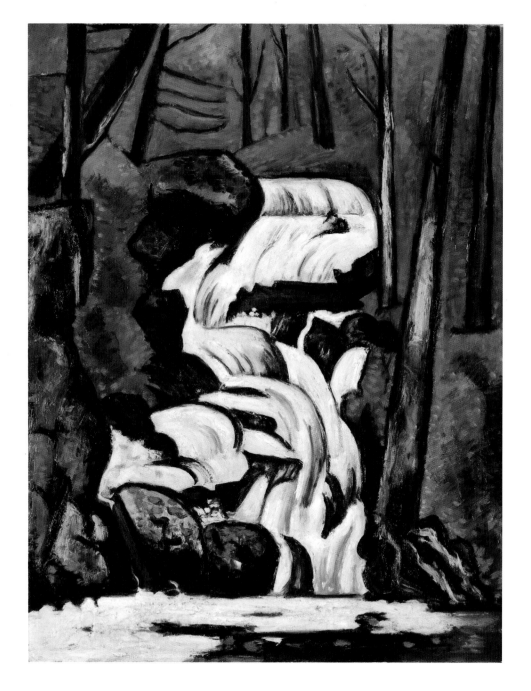

MARSDEN HARTLEY, Smelt Brook Falls, 1937,
Oil on board, 28 x 22 inches

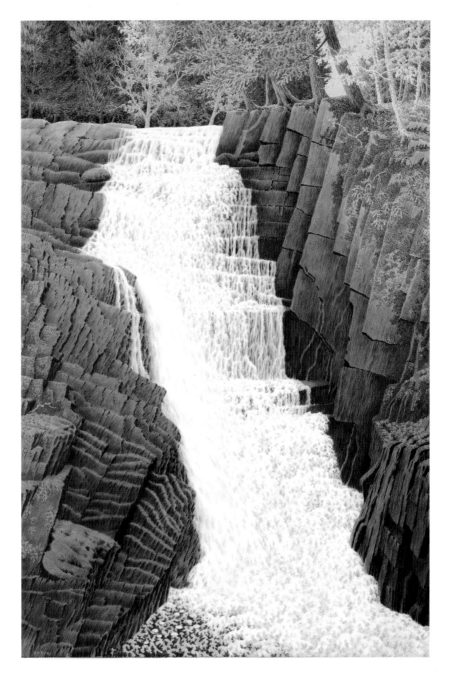

And now i must turn

to another of the beautifiers of the earth—the Waterfall;
which in the same object at once presents to the mind the
beautiful, but apparently incongruous idea, of fixedness and
motion—a single existence in which we perceive unceasing
change and everlasting duration. The waterfall may be called
the voice of the landscape, for, unlike the rocks and woods
which utter sounds as the passive instruments played on by
the elements, the waterfall strikes its own chords, and rocks
and mountains re-echo in rich unison.

Thomas Cole, *Essay on American Scenery.* 1836

Alan Bray, Wilson Falls, 1994, Casein on panel, 36 x 24 1/8 inches

I HAVE NEVER SEEN THE BEAUTY OF SPRING BEFORE;
which is something I have lived and suffered for. The landscape and the air are full
of promise. That eloquent little fruit tree that we looked at together, like a spirit among
the more earthly colors, is already losing its fairy blossoms, showing the lesson of life;
how alert we must be if we would have its gifts and values.

ALBERT PINKHAM RYDER, Letter to J. Alden Weir, 1897

ALBERT PINKHAM RYDER, Weir's Orchard, c. 1885–1890, Oil on canvas, 17 1/16 x 21 inches

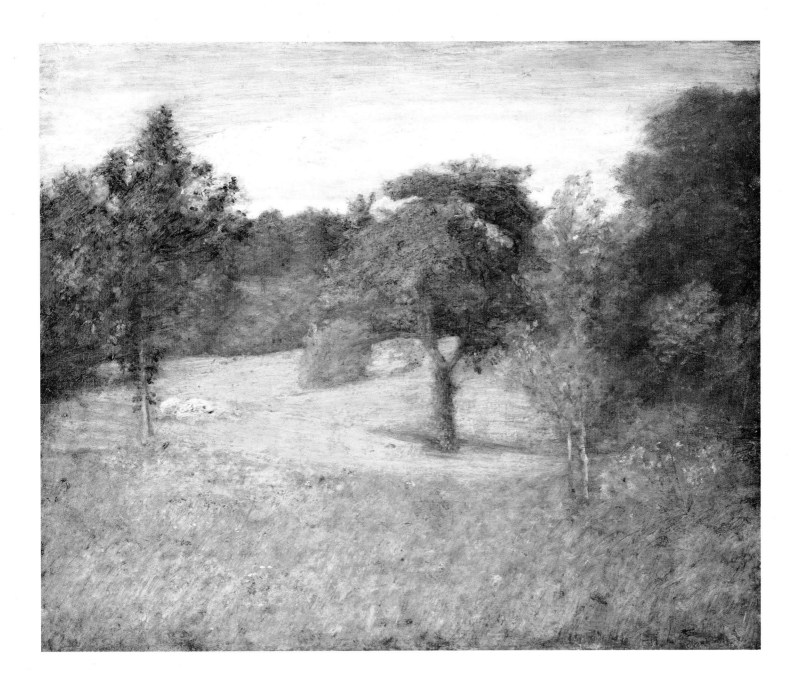

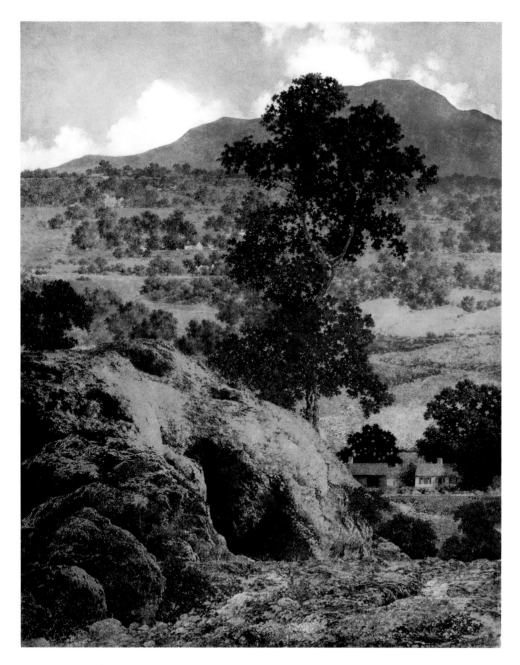

I FEEL THAT THE BROAD EFFECT, the truth of nature's mood attempted, is the most important, has more appeal than the kind of subject. "Broad effect" is a rather vague term, but what is meant is that those qualities which delight us in nature—the sense of freedom, pure air and light, the magic of distance, and the saturated beauty of color, must be convincingly stated. . . . If these abstract qualities are not in painting it is a flat failure. . . .

MAXFIELD PARRISH,
From a letter to Brown and Bigelow, 1935

MAXFIELD PARRISH, New Hampshire Hills, 1932,
Oil on panel, 23 x 18 5/8 inches

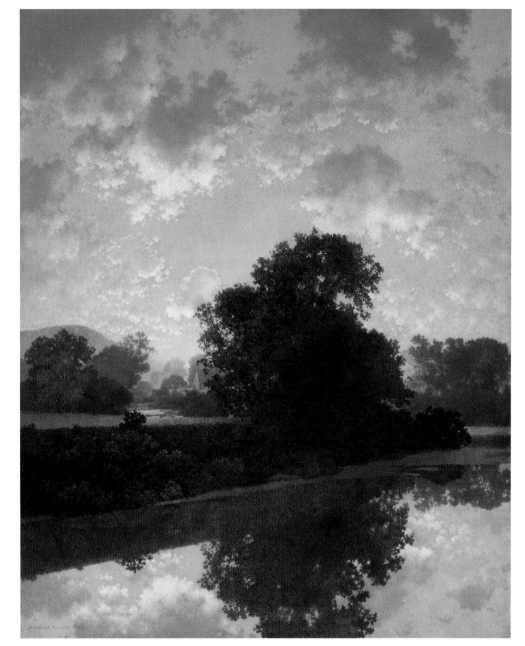

MAXFIELD PARRISH, The River at Ascutney, 1942,
Oil on panel, 23 x 18 1/2 inches

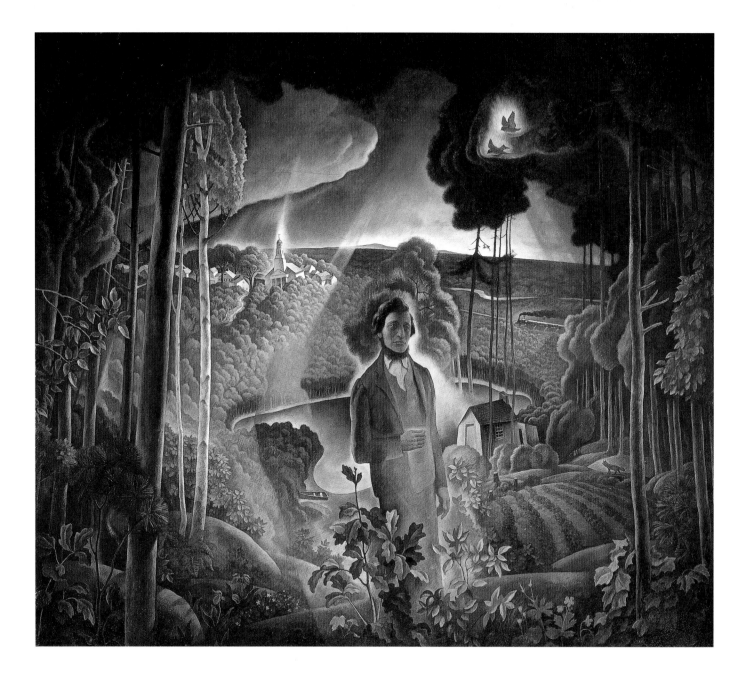

I_N SUCH A DAY, IN SEPTEMBER OR OCTOBER,

Walden is a perfect forest mirror, set round with stones as precious to my eye as
if fewer or rarer. Nothing so fair, so pure, and at the same time so large, as a lake,
perchance, lies on the surface of the earth. Sky water. It needs no fence. Nations
come and go without defiling it. It is a mirror which no stone can crack, whose
quicksilver will never wear off, whose gilding Nature continually repairs; no storms,
no dust, can dim its surface ever fresh;—a mirror in which all impurity presented to
it sinks, swept and dusted by the sun's hazy brush,—this the light dustcloth,—
which retains no breath that is breathed on it, but sends its own to float as clouds
high above its surface, and be reflected in its bosom still.

H_{ENRY} D_{AVID} T_{HOREAU}, *Walden,* 1854

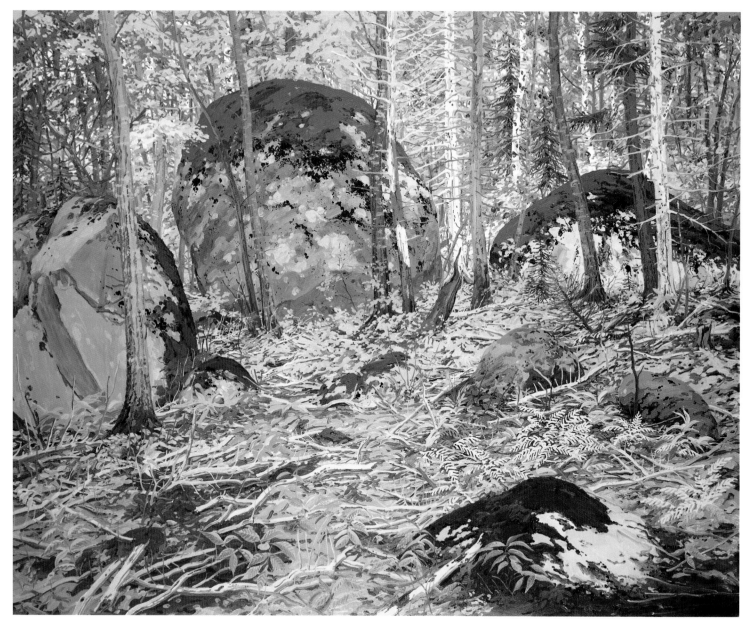

NEIL WELLIVER, Big Erratics, 1977, Oil on canvas, 96 1/4 x 120 1/8 inches

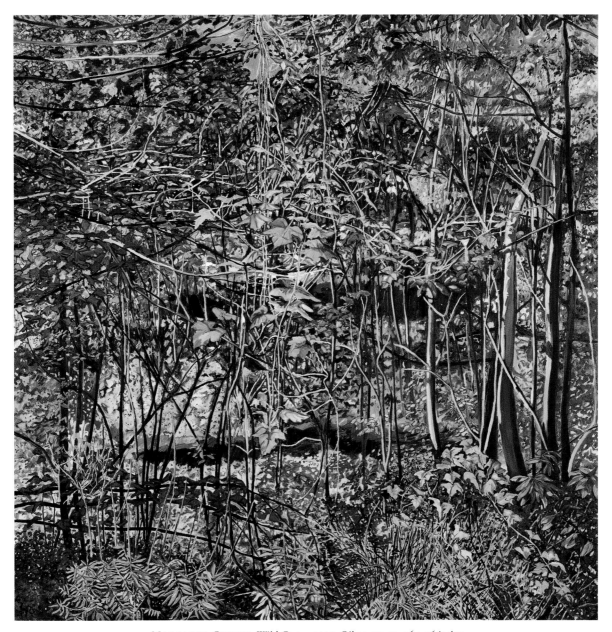

MARGARET GRIMES, Wild Grape, 1995, Oil on canvas, 56 x 56 inches

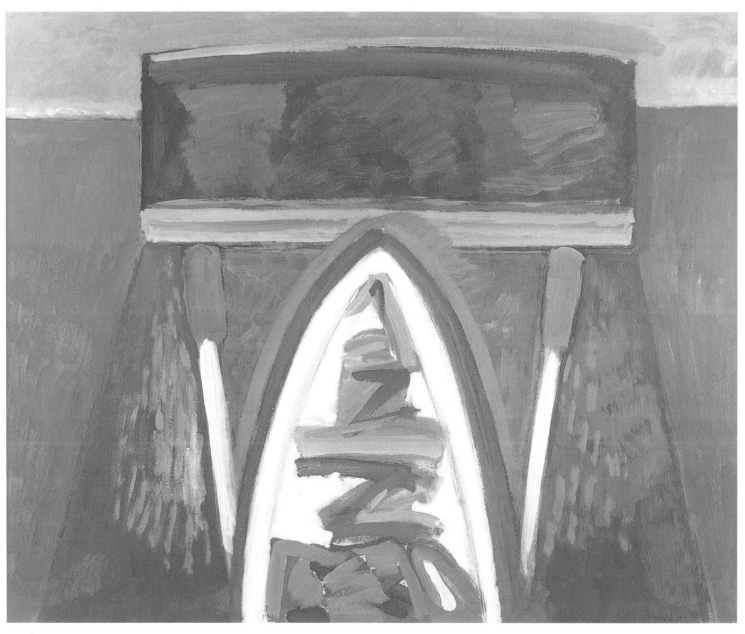

WILLIAM KIENBUSCH, Rowboat to Island #2, 1973, Casein on paper, 32 x 40 1/4 inches

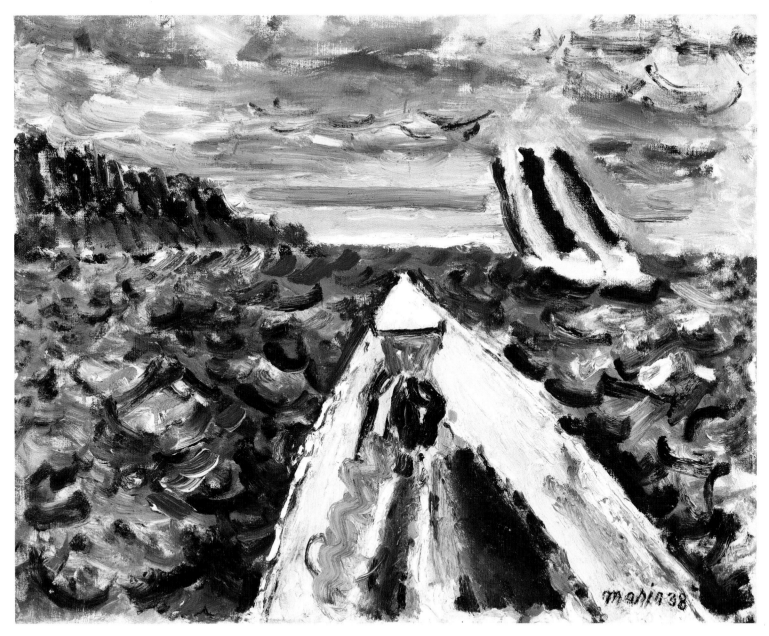

JOHN MARIN, Lobster Boat, Cape Split, Maine, 1938, Oil on canvas, 22 1/4 x 28 inches

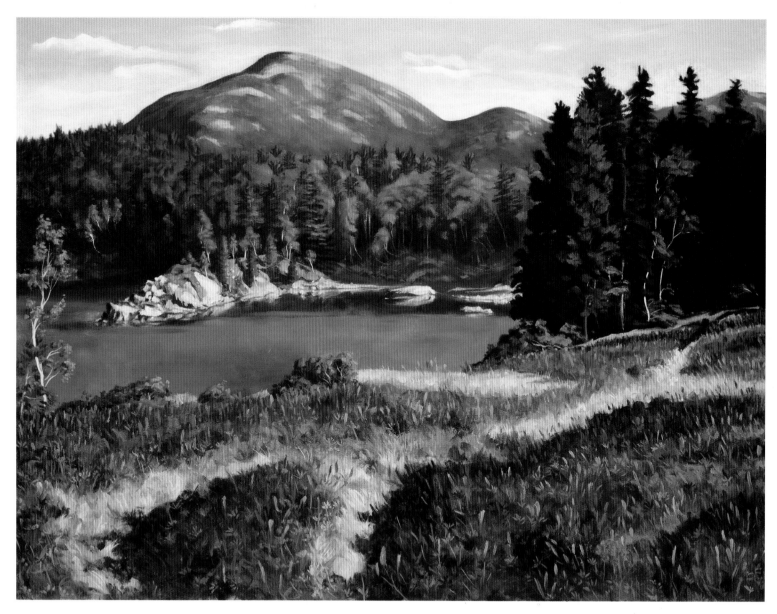

JOELLYN DUESBERRY, Cadillac Mountain, Acadia National Park, 1987, Oil on linen, 18 x 24 inches

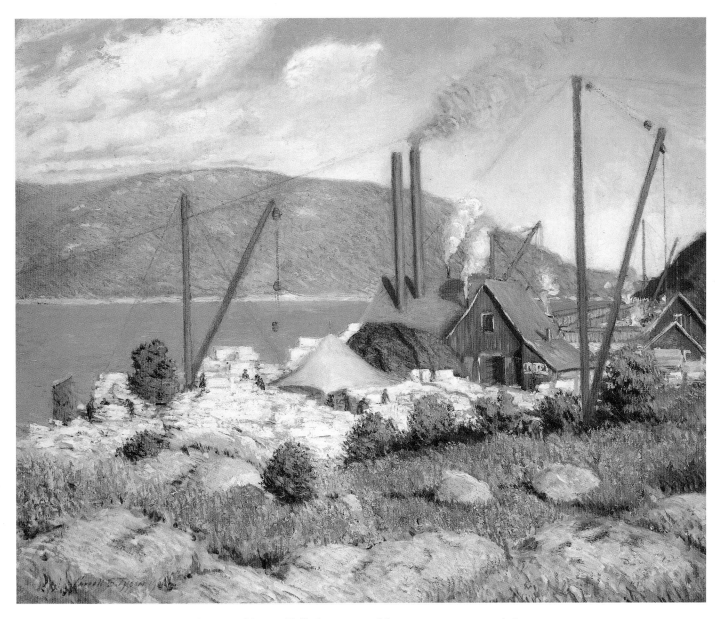

CARROLL TYSON, Hall's Quarry, 1905, Oil on canvas, 25 1/8 x 30 1/8 inches

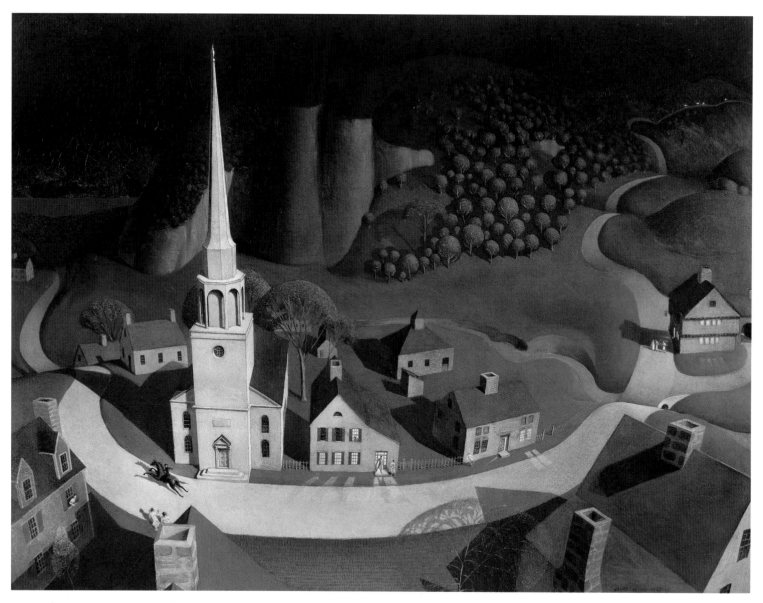

GRANT WOOD, *Midnight Ride of Paul Revere*, 1931, Oil on composition board, 30 x 40 inches

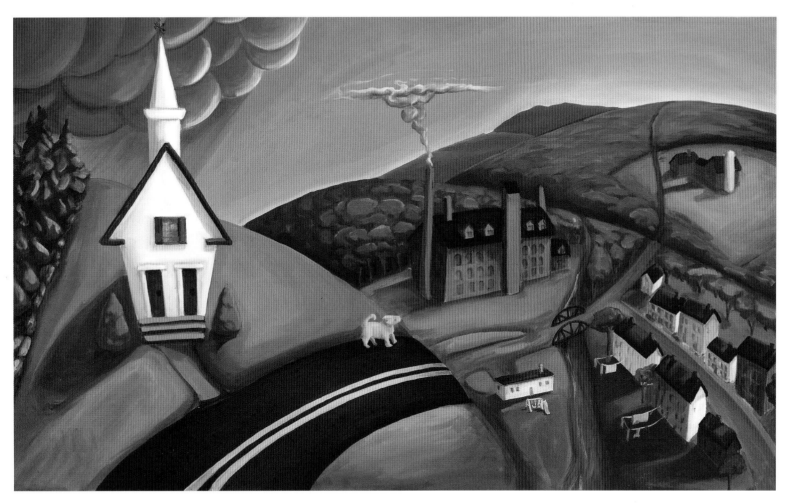

JANICE KASPER, New England, 1995, Oil on canvas, 18 x 30 inches

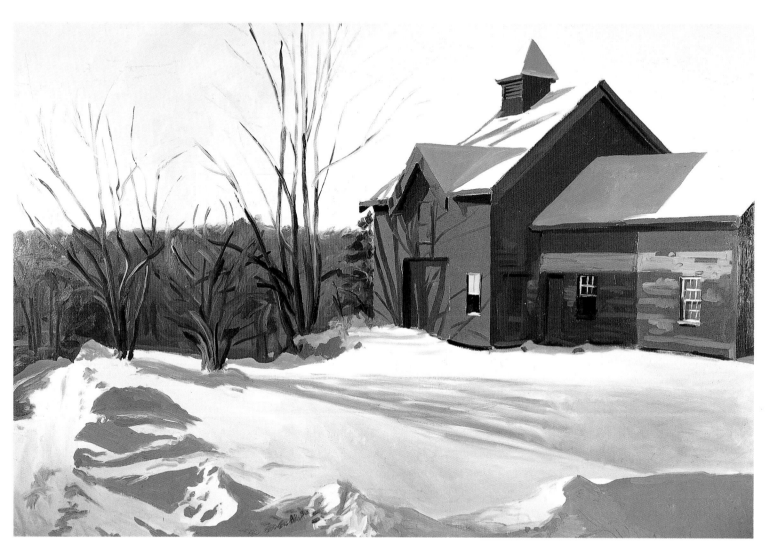

George Nick, Red Barn in Snow, Concord, 1982, Oil on canvas, 40 x 60 inches

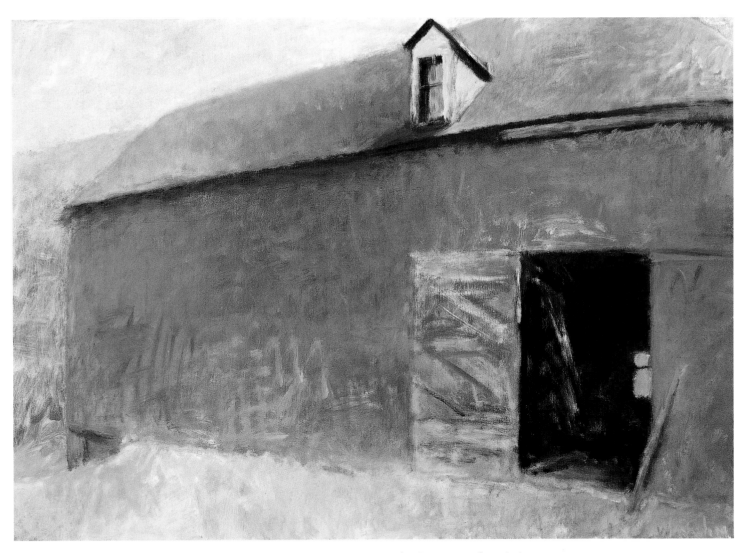

WOLF KAHN, Green Barn Window, 1986, Oil on canvas, 36 x 52 inches

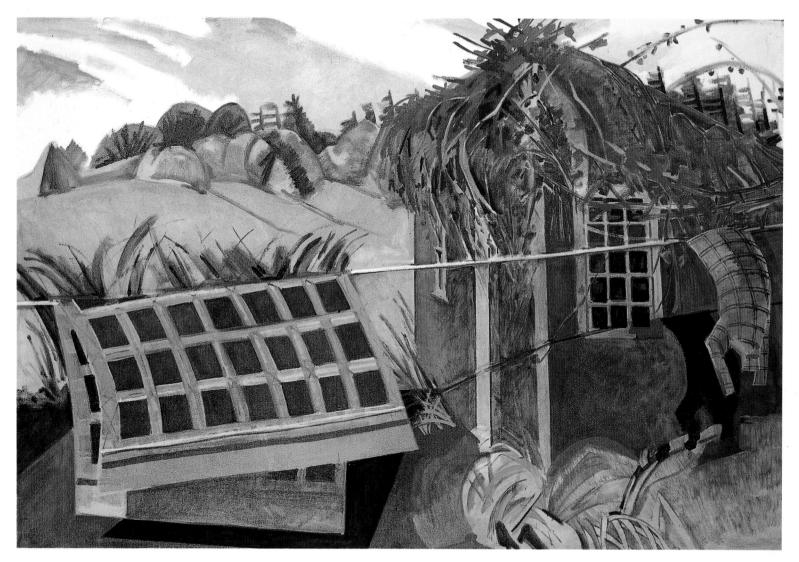

Lois Dodd, Red Vine and Blanket, 1979, Oil on linen, 40 x 60 inches

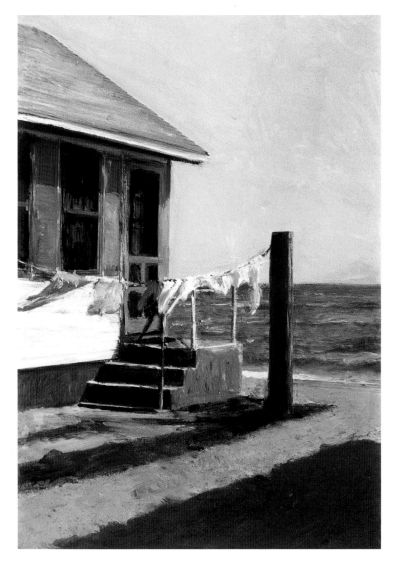

BLANKETS on the line
To be folded with sun in them,
Oil in the door-lock
(Why bother the spider now?),
Pillows brought in from the porch,
And the canvas swing
(Spray from the Atlantic will fly here);
The wood-pile left safe and dry
Where the red squirrel shall nest,
And hear in his sleep the winds howl.

On the kitchen shelf,
Preserves, baking powder,
Yes, and a little flour in the crock
(No stiffening ant shall make his way here),
A little coffee in the jar.

Going from room to room,
Thinking forward to another summer
(Blue days, cloud shadows on mountains),
I feel the cold waiting—
Know how icy to touch
Will be my pancake turner,
And hear in the night
The crack of the witch hazel bottle.

HORTENSE FLEXNER, *Closing the House*

ELIZABETH SOLOMON, Truro Clothesline, 1994, Mixed media, 5 x 3 1/2 inches

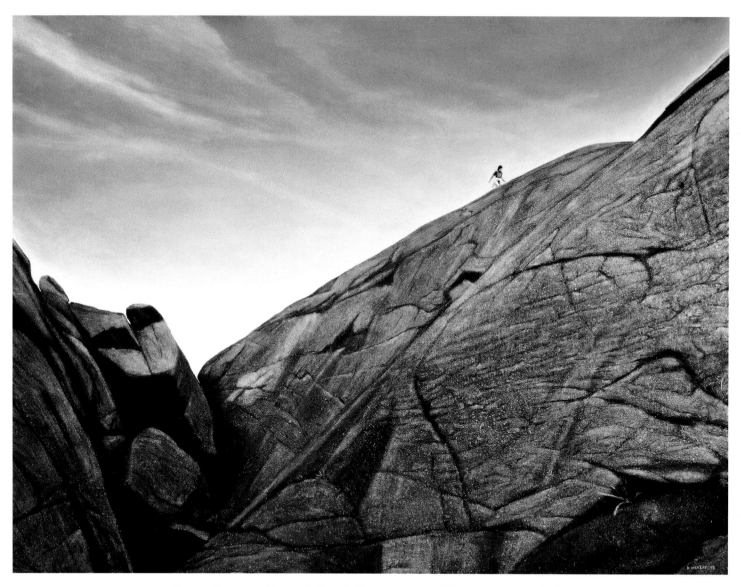

DAVID VICKERY, Kate on Gull Rock, Monhegan, 1993, Oil on canvas, 30 x 40 inches

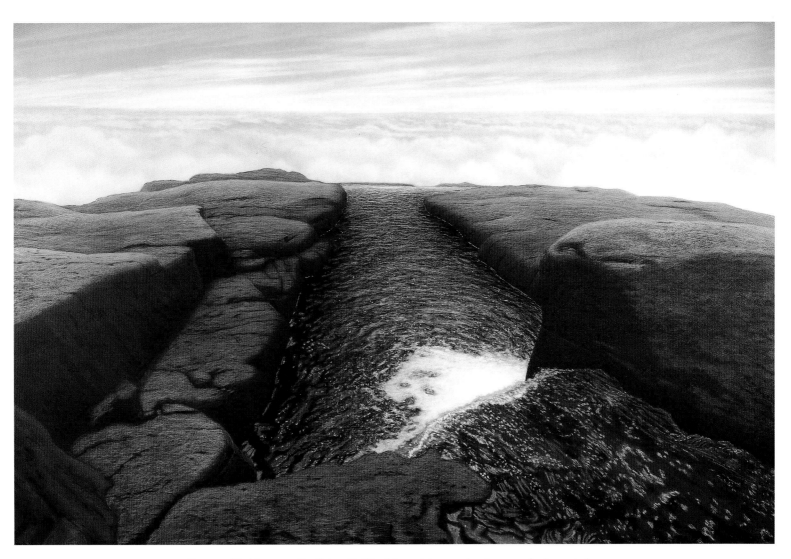

ERNEST MCMULLEN, Fog Below (Cadillac Mountain), 1992, Acrylic on panel, 48 x 72 inches

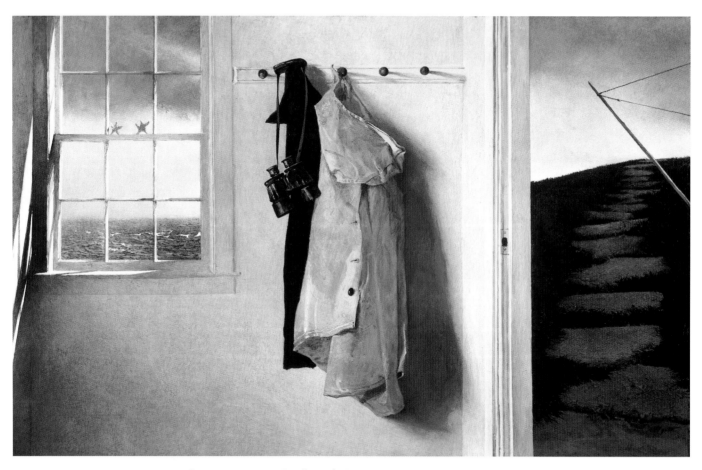

ANDREW WYETH, Squall, 1986, Tempera on panel, 17 3/4 x 28 1/2 inches

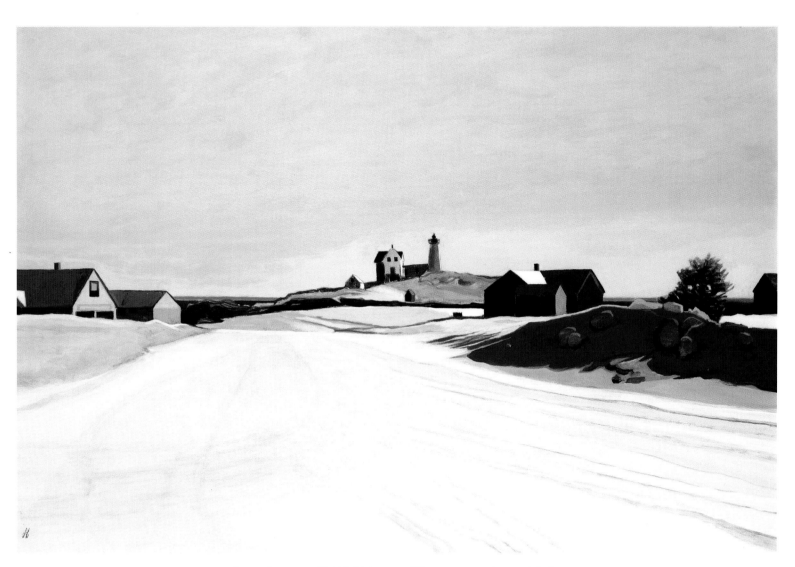

JOHN LAURENT, Nubble Light, 1977, Oil on canvas, 23 3/4 x 35 1/2 inches

NOW THE ONELY WAY TO AVOYDE THIS SHIPWRACKE,

and to provide for our posterity, is to followe the counsell of Micah, to doe justly, to love mercy, to walke humbly with our God. For this end, wee must be knitt together in this work as one man... Soe shall wee keepe the unitie of the spirit in the bond of peace... Wee shall finde that the God of Israell is among us, when tenn of us shall be able to resist a thousand of our enemies; when hee shall make us a prayse and glory that men shall say of succeeding plantations, 'the lord make it like that of NEW ENGLAND.' For wee must consider that wee shall be as a Citty upon a hill.

JOHN WINTHROP, ESQUIRE, Governor of Massachusetts, *A Model of Christian Clarity,* 1630

DAVID F. UTIGER, City on the Hill, 1991, Mixed media, 16 x 27 inches

Credits

Anonymous
New England Village, early 19th century
Oil on wood, 12 3/8 x 25 9/16 in.
National Gallery of Art
Gift of Edgar William & Bernice Chrysler Garbisch
29

Avery, Milton
Vermont Hills, 1936
Oil on canvas, 32 x 48 in.
Rose Art Museum, Brandeis University, Waltham, MA
Gift of Mr. Roy R. Neuberger, 1951
Photo by Muldoon Studio—Waltham, MA
95

Bellows, George Wesley
Ox Team, Matinicus, 1916
Oil on canvas, 22 x 28 in.
Metropolitan Museum of Art
Gift of Mr. & Mrs. Raymond Horowitz, 1974
70

Bellows, George Wesley
Tennis Tournament, 1920
Oil on canvas, 59 x 66 in.

KARL SCHRAG
Sandbar in Autumn, 1986
Oil on canvas, 26 x 32 inches

National Gallery of Art
Collection of Mr. & Mrs. Paul Mellon
85

Benn, Ben
Landscape, Flowers and Cow, 1915
Oil on canvas, 27 x 22 in.
Babcock Galleries, New York
17

Benton, Thomas Hart
Picnic, 1943
Oil and tempera on canvas on panel, 48 x 36 in.
Jordan-Volpe Gallery, New York
86

Benton, Thomas Hart
The Cliffs, 1921
Oil on canvas, 29 x 34 5/8 in.
Hirshhorn Museum and Sculpture Garden
Smithsonian Institution
Gift of Joseph H. Hirshhorn, 1966
Photo by Lee Stalsworth
88

Bluemner, Oscar
Walls of New England, 1935

Casein varnish on insulite panel, 36 x 48 in.
Jordan-Volpe Gallery, New York
74

Blume, Peter
Winter, New Hampshire, 1927
Oil on canvas, 20 1/4 x 25 in.
Museum of Fine Arts, Boston
Bequest of John T. Spaulding
72

Bray, Alan
Wilson Falls, 1994
Casein on panel, 36 x 24 1/8 in.
Schmidt Bingham Gallery, New York
97

Bricher, Alfred Thomas
Point Judith, Narragansett, Rhode Island, c. 1885
Oil on canvas, 13 x 29 in.
Babcock Galleries, New York
Title page

Bryden, Lewis
Sunderland—View from Mt. Sugarloaf, 1994
Oil on canvas, 28 x 38 in.
R. Michelson Galleries, Northampton, MA
Photo by Stephen Petegorsky
20

Cahoon Jr., Ralph Eugene
Duck Hunting, New England, c. 1950
Oil on masonite, 24 x 34 in.
Aaron Galleries, Chicago
6

Chaet, Bernard
Vermont Yellows, 1991
Oil on canvas, 18 x 40 in.
Alpha Gallery, Boston
Photo by Boston Photo Imaging
93

Church, Frederic Edwin
West Rock, New Haven, 1849
Oil on canvas, 26 1/2 x 40 in.
New Britain Museum of American Art, CT
John B. Talcott Fund
Photo by E. Irving Blomstrann
42

Cole, Charles Octavius
Imperial Knob and Gorge:
White Mountains of New Hampshire, 1853
Oil on canvas, 44 7/8 x 36 1/8 in.
Brooklyn Museum
Dick S. Ramsay Fund
37

Cole, Thomas
A View of the Mountain Pass Called the Notch
of the White Mountains (Crawford Notch), 1839
Oil on canvas, 53 1/2 x 74 5/8 in.
National Gallery of Art
Andrew W. Mellon Fund
38

Cole, Thomas
View from Mount Holyoke, Northampton, Massachusetts,
after a Thunderstorm—The Oxbow, 1836
Oil on canvas, 51 1/2 x 76 in.
Metropolitan Museum of Art
Gift of Mrs. Russell Sage, 1908
40

Crotty, Thomas
Vinalhaven, 1996
Oil on canvas, 60 x 60 in.
Frost Gully Gallery, Portland, ME
128

Davis, Stuart
Landscape with Drying Sails, 1931–32
Oil on canvas, 32 x 40 in.
Columbus Museum of Art, Ohio
Museum Purchase: Howald Fund II, 1981
14

DeCamp, Joseph
Seascape, 1911
Oil on canvas, 25 x 30 in.
William A. Farnsworth Library and Art Museum
54

DeGrailly, Victor
Eastport and Passamaquoddy Bay, c. 1840
Oil on canvas, 17 1/4 x 23 1/2 in.
Portland Museum of Art
34

Dickinson, Edwin
Lieutenant Island from Indian Rock, 1946
Oil on canvas, 16 x 20 in.
Babcock Galleries, New York
80

Dodd, Lois
Red Vine and Blanket, 1979
Oil on linen, 40 x 60 in.
Fischbach Gallery, New York
Photo by Bob Brooks, New York
114

Duesberry, Joellyn
Cadillac Mountain, Acadia National Park, 1987
Oil on linen, 18 x 24 in.
Collection of Dr. Charles Hamlin
108

Elmer, Edwin Romanzo
Mourning Picture, 1890
Oil on canvas, 28 x 36 in.
Smith College Museum of Art, Northampton, MA
77

Fisher, Jonathan
A Morning View of Blue Hill Village, 1824
Oil on canvas, 25 5/8 x 52 1/4 in.
William A. Farnsworth Library and Art Museum
30

Ford, Lauren
The Country Doctor, c. 1935
Oil on canvas, 54 x 72 in.
Canajoharie Library and Art Gallery
69

Frost, John Orne Johnson
Indian Encampment at Salem Harbor Side, c. 1920s
Oil on beaver board, 47 1/2 x 70 1/2 in.
Shelburne Museum, Shelburne, VT
Photo by Ken Burris
31

Gifford, Sanford Robinson
The Artist Sketching at Mount Desert, Maine, 1864–65
Oil on canvas, 11 x 19 in.
Collection of Jo Ann & Julian Ganz, Jr.
9

Gilchrist, William Wallace
Congress Square in Winter, c. 1915
Oil on canvas, 20 x 26 in.
Portland Museum of Art
Gift of Dr. Carl & Linda Metzger
Photo by Melville D. McLean
65

Glackens, William J.
Beach Scene, New London, 1918
Oil on canvas, 26 x 31 7/8 in.
Columbus Museum of Art, Ohio
Gift of Ferdinand Howald
84

Griffin, G. J.
View of Freeport, Maine, 1886
Oil on canvas, 21 x 39 in.
Colby College Museum of Art
28

Grimes, Margaret
Wild Grape, 1995
Oil on canvas, 56 x 56 in.
Collection of the Artist
105

Hallam, Beverly
Big Mussel, 1965
Acrylic and mica talc on Belgian linen, 84 x 48 in.
Addison Gallery of American Art
Phillips Academy, Andover, MA
18

Hallowell, George Hawley
Crown of New England, c. 1905
Oil on canvas, 28 x 47 in.
DeMartine-Fredman Collection
60

Hannock, Stephen
The Oxbow, After Church, After Cole, Flooded 1979–1994
(Flooded River for the Matriarchs: E. and A. Mongan), 1994
Polished oil on canvas, 54 x 81 in.
Smith College Museum of Art
Gift of Irene Mennen Hunter ('39)
Courtesy of R. Michelson Galleries, Northampton, MA
41

Hartley, Marsden
Smelt Brook Falls, 1937
Oil on board, 28 x 22 in.
Saint Louis Art Museum
Purchase: Eliza McMillan Fund
96

Hartley, Marsden
Windy Day, Maine Coast, 1941
Oil on canvas, 20 1/4 x 16 1/8 in.
Munson-Williams-Proctor Institute
Anonymous Gift
16

Hassam, Childe
Church at Old Lyme, 1903
Oil on canvas, 37 x 29 in.
Babcock Galleries, New York
66

Hassam, Childe
Rainy Day, Boston, 1885
Oil on canvas, 26 1/8 x 48 in.
Toledo Museum of Art, Ohio
Purchased with funds from the Florence Scott Libbey
 Bequest in Memory of her Father, Maurice A. Scott
64

Heade, Martin Johnson
Newburyport Marshes: Passing Storm, c. 1865–70
Oil on canvas, 15 x 30 in.
Bowdoin College Museum of Art, Brunswick, ME
Museum purchase with the aid of the
 Sylvia E. Ross Fund
43

Heade, Martin Johnson
Thunderstorm On Narragansett Bay, 1868
Oil on canvas, 32 1/8 x 54 1/2 in.
Amon Carter Museum
51

Hill, Edward
Snow Arch at Tuckerman's Ravine, 1884
Oil on canvas, 14 15/16 x 15 3/16 in.
Hood Museum of Art, Dartmouth College, Hanover, NH
36

Hirsch, Stefan
Factories, Portsmouth, New Hampshire, 1930
Oil on canvas, 17 1/4 x 27 in.
Collection of SBC Communications Inc.
Photo courtesy of Richard York Gallery, New York
75

Homer, Winslow
Artists Sketching in the White Mountains, 1868
Oil on panel, 9 7/16 x 15 13/16 in.
Portland Museum of Art
Bequest of Charles Shipman Payson
Photo by Melville McLean
Half-title

Homer, Winslow
Watching the Breakers—A High Sea, 1896
Oil on canvas, 24 x 38 in.
Canajoharie Library and Art Gallery
53

Hopper, Edward
Cottages at North Truro, Massachusetts, 1938
Watercolor, 20 3/16 x 28 1/8 in.
Ebsworth Collection
Collection of Mr. & Mrs. Barney A. Ebsworth
81

Hopper, Edward
First Branch of the White River, VT, 1938
Watercolor, 19 3/4 x 25 in.
Museum of Fine Arts, Boston
William Emerson Fund
Courtesy of Museum of Fine Arts, Boston
Frontispiece

Hultberg, John
Daybreak Over Island, 1962
Oil on canvas, 48 x 76 in.
David Anderson Gallery, Buffalo, NY
Photo by Elizabeth Davis
91

Huntington, Christopher
The Mountain, c. 1980
Oil on canvas, 16 x 24 in.
Collection of Key Bank of Maine, Portland, ME
Courtesy of the Frost Gully Gallery, Portland, ME
24

Inness, George
Saco Ford: Conway Meadow, 1876
Oil on canvas, 38 x 63 in.
Mount Holyoke College Art Museum, South Hadley, MA
48

Isaacs, Henry
Mt. Mansfield from Johnson, VT, #2, 1991
Oil on canvas, 24 x 18 in.
Collection of the Artist
25

Johnson, Eastman
The Cranberry Harvest, Island of Nantucket, 1880
Oil on canvas, 27 1/2 x 54 5/8 in.
Timken Art Gallery
The Putnam Foundation
Timken Museum of Art, San Diego
44–45

Kahn, Wolf
Green Barn Window, 1986
Oil on canvas, 36 x 52 in.
DC Moore Gallery, New York
113

Kasper, Janice
New England, 1995
Oil on canvas, 18 x 30 in.
Collection of Julia B. Leisenring
Photo by William Thuss
111

Kensett, John Frederick
Almy Pond, Newport, 1855–1859
Oil on canvas, 12 5/8 x 22 1/8 in.
Terra Foundation for the Arts
Daniel J. Terra Collection
Terra Museum of American Art, Chicago
46

Kensett, John Frederick
New England Sunrise, c. 1863
Oil on canvas, 18 x 30 1/4 in.
Babcock Galleries, New York
50

CARL SPRINCHORN, *Woodcutters and Teams,* c. 1940,
Watercolor on paper, 18 x 20 inches

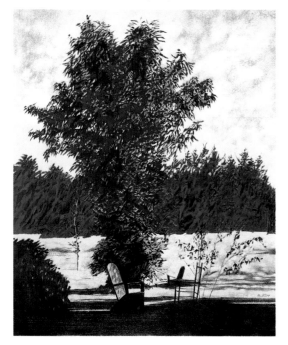

DANIEL LANG, Three Chairs at Ilyria, 1986
Oil on canvas, 48 x 40 inches

Prendergast, Maurice
New England Harbor, c. 1919–23
Oil on canvas, 24 x 28 in.
Cincinnati Art Museum, Ohio
63

Prendergast, Maurice
South Boston Pier, 1896
Watercolor over graphite, 18 1/8 x 13 5/16 in.
Smith College Museum of Art, Northampton, MA
Purchased: Charles B. Hoyt Fund, 1950
62

Ryder, Albert Pinkham
Weir's Orchard, c. 1885–1890
Oil on canvas, 17 1/16 x 21 in.

Wadsworth Atheneum
The Ella Gallup Sumner & Mary Catlin Sumner
 Collection Fund
99

Salmon, Robert
Shipping Off Boston Light, c. 1830
Oil on panel, 16 x 24 in.
Babcock Galleries, New York
32

Sample, Paul Starrett
Beaver Meadow, 1939
Oil on canvas, 40 x 48 1/4 in.
Hood Museum of Art, Dartmouth College, Hanover, NH
Gift of the artist, Paul Sample, Class of 1920
 in memory of his brother, Donald M. Sample
Class of 1921
76

Schrag, Karl
Sandbar in Autumn, 1986
Oil on canvas, 26 x 32 in.
Kraushaar Gallery, New York
122

Sloan, John
Dogtown (Gloucester), 1916
Oil on canvas, 20 1/4 x 24 1/4 in.
Cape Ann Historical Association Collections
57

Sloan, John
Red Rocks and Quiet Sea No. 2, 1916
Oil on canvas, 26 x 32 in.
Regis Collection
56

Smith, Houghton Cranford
Reflections, Shadow Lake, Glover, Vermont, c. 1940
Oil on canvas, 33 x 53 in.
Richard York Gallery, New York
92

Solomon, Elizabeth
Truro Clothesline, 1994
Mixed media, 5 x 3 1/2 in.
Private Collection
115

Sonntag, William
Evening in the Mountains, c. 1863
Oil on canvas, 12 x 20 in.
Babcock Galleries, New York
39

Spencer, Niles
Back of the Town (Provincetown), 1926
Oil on canvas, 30 1/4 x 36 1/4 in.
Dallas Museum of Art
Anonymous Collector, Dallas, Texas
79

Sprinchorn, Carl
Woodcutters and Teams, c. 1940
Watercolor on paper, 18 x 20 inches
DeMartine-Fredman Collection
125

Thompson, Jerome
The Belated Party on Mansfield Mountain, 1858
Oil on canvas, 38 x 63 1/8 in.
Metropolitan Museum of Art
Rogers Fund, 1969
35

Twachtman, John Henry
End of Winter, after 1889
Oil on canvas, 22 x 30 1/8 in.
National Museum of American Art
Gift of William T. Evans
Photo by National Museum of American Art,
 Washington, D.C./Art Resource, NY
58

Tyson, Carroll
Hall's Quarry, 1905
Oil on canvas, 25 1/8 x 30 1/8 in.
White House Historical Association
109

Utiger, David F.
City on the Hill, 1991
Mixed media, 16 x 27 in.
Private Collection
121

Van Ness, Beatrice Whitney
Whitecaps, c. 1926
Oil on canvas, 18 x 22 in.
William A. Farnsworth Library and Art Museum
55

Vickery, David
Kate on Gull Rock, Monhegan, 1993
Oil on canvas, 30 x 40 in.
Collection of Nancy Schakel
116

Webster, Edwin Ambrose
Brook in Winter, c. 1914
Oil on canvas, 29 1/2 x 39 1/2 in.
Babcock Galleries, New York
59

Weir, J. Alden
Midday Rest in New England, 1897
Oil on canvas, 39 5/8 x 50 3/8 in.
Museum of American Art of the Pennsylvania
Academy of Fine Arts, Philadelphia
Gift of Isaac H. Clothier, Edward H. Coates,
 Dr. Francis W. Lewis, Robert C. Ogden & Joseph
 G. Rosengarten.
71

Welliver, Neil
Big Erratics, 1977
Oil on canvas, 96 1/4 x 120 1/8 in.
Hirshhorn Museum and Sculpture Garden,
Smithsonian Institution
Museum Purchase, 1977
Photo by John Tennant
104

Whiting, Allen
Oak Trees at Big Sandy, 1995
Oil on canvas, 36 x 50 in.
Chase Gallery
Collection of Oppenheimer & Co., Inc.
Courtesy of Chase Gallery, Boston.
127

Whittredge, Worthington
A Breezy Day—Sakonnet Point, Rhode Island, c. 1880
Oil on canvas, 25 3/8 x 38 1/2 in.
Amon Carter Museum
47

Wood, Grant
Midnight Ride of Paul Revere, 1931
Oil on composition board, 30 x 40 in.
Metropolitan Museum of Art,
Arthur Hoppock Hearn Fund, 1950
110

Woodbury, Charles H.
In the Surf, Ogunquit, 1912
Watercolor on paper, 17 x 21 inches
DeMartine-Fredman Collection
82

Wyeth, Andrew
Squall, 1986
Tempera on panel, 17 3/4 x 28 1/2 inches
Collection of Yoji Takahishi, Japan
© 1995, by Andrew Wyeth
118

Wyeth, James
Giant Clam, 1977
Watercolor on paper, 34 x 23 inches
Collection of Dolly Bruni Havard
19

Wyeth, N. C.
Walden Pond Revisited, 1942
Tempera, possibly mixed with other media, on panel
42 x 48 in.
Brandywine River Museum
Bequest of Miss Carolyn Wyeth
102

Zorach, Marguerite
City of Bath, c. 1927
Oil on canvas, 18 x 30 in.
William A. Farnsworth Library and Art Museum
Gift of Dahlov Ipcar & Tessim Zorach, 1986
90

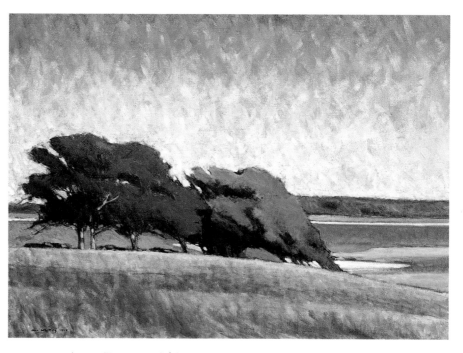

ALLEN WHITING, Oak Trees at Big Sandy, 1995, Oil on canvas, 36 x 50 in.

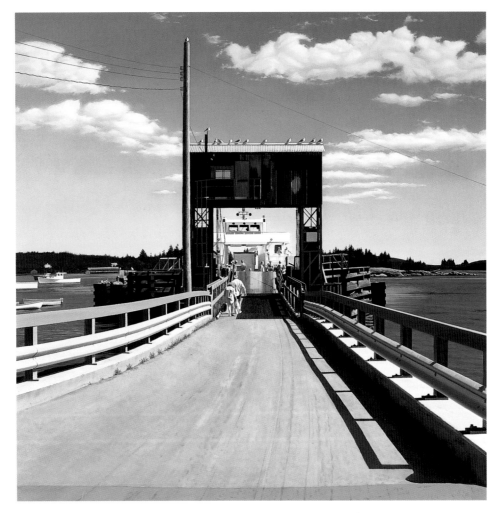

THOMAS CROTTY, Vinalhaven, 1996, Oil on canvas, 60 x 60 inches

THERE IS SOMETHING ABOUT CROSSING OVER WATER
which puts the mainland and one's ordinary life behind, and takes one into
a new world.

ELIZABETH COATSWORTH, *New World*, 1947